IMAGES
of America

RUNNING SPRINGS

ON THE COVER: John E. Brookings, first cousin to the founder of the Brookings Institution, leads a hunting party of friends near Hunsaker Flats, today's Running Springs, in this photograph from 1900. Suits, ties, and hats were required.

IMAGES
of America

RUNNING SPRINGS

Stanley E. Bellamy

ARCADIA
PUBLISHING

Published by Arcadia Publishing
Charleston SC, Chicago IL, Portsmouth NH, San Francisco CA

Printed in the United States of America

Library of Congress Catalog Card Number: 2006928746

For all general information contact Arcadia Publishing at:
Telephone 843-853-2070
Fax 843-853-0044
E-mail sales@arcadiapublishing.com
For customer service and orders:
Toll-Free 1-888-313-2665

Visit us on the Internet at www.arcadiapublishing.com

This book is dedicated to Jim Sims and Tom Preston. Both of these longtime residents of Running Springs are representative of the dedication of many individuals of this community.

CONTENTS

ACKNOWLEDGMENTS

Among those who inspired this work are former students who introduced me to our local history. This came about as the result of an assignment I had given them: to write a report about their community's history. As a new teacher to the Rim of the World Unified School District, I was not familiar with the history of the area and wanted to see if the students could educate me in some way about it. To my pleasure and surprise, they not only completed their assignments with interviews, photographs, maps, and firsthand accounts, many of those who were descendants of the first pioneers even presented original family histories. Two of my students, Harold Halldorson and Danny Bell, took me on a field trip, and I saw where the Brookings sawmill had been and the existing rail beds. Student Hank Doring came across a trash pile on his way to school that produced old notebooks and photographs by a photographer who had recently died. His wife and daughter were "cleaning house." I contacted them and was able to purchase more photographs.

In the Talmud, we read the following:

> Much I have learned from my teachers, even more from my classmates,
> but most from my students.
> All teachers know how true this statement is and I value my students' willingness to share their discoveries with me.

Contributors to this book include Dolly Ball; Marge Barrett of the *Humboldt* (Brookings, Oregon) *Times*; Dale Bauer; H. N. Kinney Brookings; Bill Calvert; "Speed" Donaldson; former student Kathleen Ferrara, who read and suggested changes to vital passages; Roger Hathaway; Russ Keller; Mike Kessler; Troy Letourneau; Robert MacColl; Colby Miller; Florence Montgomery; Michael Oliver; Ray Poppett; Tom Preston; the Rose Hawley Museum of Mason County's Michigan Historical Society; Nancy Seccombe; Steele's Photo Service; Mr. and Mrs. Richard Tucker; Darien Wood; and Kenny Wood. My special thanks to Michele Nielsen, curator for the San Bernardino County Museum, and museum attendants Andy Savala and Cindy Hernández, all of whom went beyond the call of duty to accommodate a request for photographs made by me.

INTRODUCTION

When the Mormons of Utah arrived at the San Bernardino Valley in 1851 (without Brigham Young's blessing), they entered through the Cajon Pass, where they looked upon an immense valley covered with mustard-seed plants, giving it a bright golden hue—perhaps a symbol of what would await them. They reported back to their brethren in Salt Lake City that they had arrived in a beautiful valley with a pleasant climate, good soil, plentiful artesian springs that flowed year-round, and streams filled with fresh mountain water coming from the melting snows in the sierras just to the north.

The Mormons built a fort to protect themselves from expected Native American raids (which never came) and began to lay out a city very similar in design to the capital of their own Utah Territory. They then explored the mountains to the north for timber to construct the buildings to house their families and provide meeting places for worship and public gatherings. Heavy timber was needed for barns, bridges, gristmills, and a school.

The shortest route into the virgin-timber areas was through a steep canyon, known today as Waterman Canyon, named for former California governor Robert Waterman, 1887–1891. With all hands available and working steadily, they reached the crest 12 miles away in 10 days. As soon as the road was completed, portable sawmills were set up at Seely Flats, Huston Flats (now known as Lake Gregory), and eastward to Long Point, near today's Running Springs, which was then owned by the Seely family. The cut timber became known as "Mormon currency" because they used it to barter for goods they couldn't pay for with cash.

In 1857, the Mormons were called back to Utah during the U.S. occupation of the territory by Johnston's army. Most of them answered the summons to return. Although before the recall, the Mormons were aware of gold in an area known today as Holcomb Valley, but chose not to mine it. Many of those who did remain became prominent citizens of the city and county and developed much of the industry there and in the mountains. Their greatest contribution is perhaps the public road they built into the mountains through Waterman Canyon, which remains today as a tribute to their dedication and industry.

From the mid-19th century and into the next, men from many parts of the world would discover the riches of the San Bernardino Mountains and fertile valleys below. In Holcomb Valley, numerous mines were in operation by 1900, and communities grew around them. But the gold ore proved too costly to process, and the mines and stamping mills eventually closed. People left, and the towns that had once served the needs of the locals lapsed into dust beside the goldfields and slag piles.

Some of these mountain miners and explorers remained, and the more visionary entrepreneurs saw golden opportunities, not only in ore but also in timber, water, and eventually in tourism. While the citrus industry was virtually exploding in Southern California, a tremendous market for timber was developing to meet the needs of the industry and to provide shelter for the thousands of people coming westward from the East. This heavy use of timber created a need for more productive sawmills that could approach the output of the mills of Oregon and Washington.

7

The small, portable water-driven or steam-driven mills of the Seelys, the Talmadges, the Tylers, the Shays, and others were not able to provide the sufficient amount of cut lumber necessary for valley businesses and lumberyards. Experienced lumbermen from the East knew what was required and implemented the same technology they were accustomed to in their sawmills to those they built in the San Bernardinos.

These entrepreneurs also realized there was a need for efficient transportation of cut timber from the mills to the customers below. Where trails currently existed, roads were needed to transport that timber. Soon the trails became wagon roads, creeks were spanned with bridges, lumber mills were built, and towns grew around them. Families came with the workers and established post offices and built schools and commissaries that provided supplies for residents and visitors who wanted to explore this new territory. A tourist industry was born when the automobile was manufactured and introduced for public use. At this point, a family could leave Pasadena or Los Angeles early in the morning and reach Fredalba, Hunsaker Flats, or Big Bear Valley by evening, where they could find available food and lodging.

Eventually the great stands of timber gave out, and the lumbermen left to continue their harvest in more profitable forests. Water, however, proved to be a valuable resource, and dams were built on the mountains streams, creating great reservoirs. Man-made lakes appeared in Huston Flats (Lake Gregory), Little Bear Valley (Lake Arrowhead), Hunsaker Flats (Lake Luring), Arrowbear, Deep Creek, Green Valley, Snow Valley, and Big Bear Valley, all of which attracted fishermen and water-sports enthusiasts. When the snows came, another industry developed, and adventurers found they could go surfing in Santa Monica in the morning, and then head to the slopes of the San Bernardinos for an afternoon of skiing. During the 1880 Census, the county recorder found fewer than 100 people living in these mountains. By the year 2000, the chamber of commerce reported that 100,000 visitors had passed through the former Hunsaker Flats, now known as Running Springs, on their way to recreational activities. Running Springs has become the main artery to all communities to the east where California Highways 330 and 18 converge. The San Bernardino National Forest is now recognized as the most-used national forest in the United States and has been designated by the Department of Agriculture as an "urban forest."

Running Springs is considered to be a "bedroom community," meaning that most commute to jobs off the mountain, leaving early in the morning and arriving home late at night. There is, however, an expanding job market on the mountain, and most services are now available locally or nearby. Running Springs is a dedicated community that supports its youth and its schools and provides sports and enrichment programs for children of all ages. In addition, there are several service organizations and religious denominations that promote the welfare of the family.

The people of Running Springs take pride in their community, their youth, and the natural beauty that surrounds them. With careful development and continued support, it will always be a preferred place to live, whether for a nature lover, a retiree, or a young family looking for a place to raise children.

One

OF STEEL, STEAM, AND STAMINA

Most Americans have heard of the Brookings Institution, which is one of the most influential independent public-policy research organizations in the country, but few know that its founder, Robert S. Brookings, played a major role in the development of Running Springs, Arrowbear, and Green Valley Lakes. His first cousin was John E. Bookings, who came to the San Bernardinos in search of timber. After searching through Florida, Arkansas, and Mississippi, John found what he was looking for in the holdings of James E. Danaher of Ludington, Michigan, who had built a large sawmill near today's Running Springs that included 7,000 acres of virgin timber. John didn't have the $260,000 needed for the purchase of the Danaher mill, but his cousin Robert S. Brookings, who made his fortune manufacturing furniture on the frontier and later became the president of Washington University, put up the funds. On May 20, 1899, the Brookings family became the owners of the Highland Box and Lumber Company.

James Danaher presented grand plans for his mill. There was talk in San Bernardino of building a railroad up City Creek all the way to Big Bear, and Danaher envisioned transporting milled lumber down the mountain via this railroad. Ice could also be shipped by train to packing plants, where oranges, lemons, and grapefruits would be boxed, iced, and shipped to markets in the East in boxes he would manufacture.

In order to accommodate this rail line, a 10 percent grade would have to be maintained, bridges and tunnels would have to be built, and many tons of steel rails would have to be laid. Though it never came to fruition, it was a fine idea, one which would have served all well today. Now thousands of people travel the same grades each day on their way to the various communities where they live or enjoy the recreational opportunities of each season. How much more pleasant it would have been to sit in a comfortable railcar, beholding the beauty of the mountains, instead of focusing ones eyes on the road ahead and on oncoming traffic!

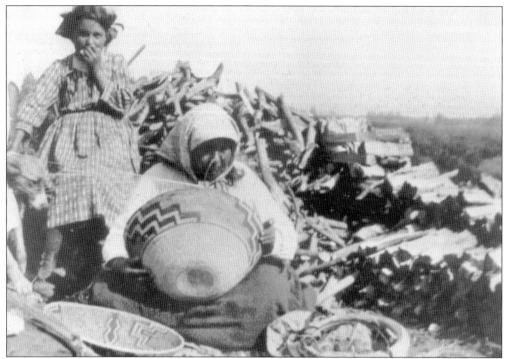

It was in 1776 that the Spanish priest Father Garcés visited the Native Americans of the San Bernardinos, who had followed their food sources into these mountains. He kept a written record of his time spent among them and called them *Serranos*, or "the mountain people." This photograph shows Luisa Pino in 1900, a member of the San Manuel Indian Tribe, making a basket. (Courtesy of the San Bernardino County Museum.)

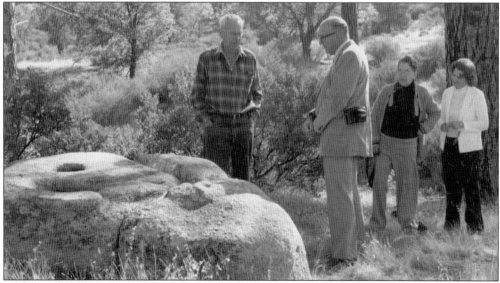

Along the Matate Trail that extends across the San Bernardino Mountains, many mortar holes where the Serranos ground acorns into meal can be found. This 1980 photograph shows, from left to right, Robert MacColl, Gerald Smith of the San Bernardino County Museum, Pauliena LaFuze, and Mr. Smith's assistant, Ann Quinn, examining one such mortar hole at Bacon Flats.

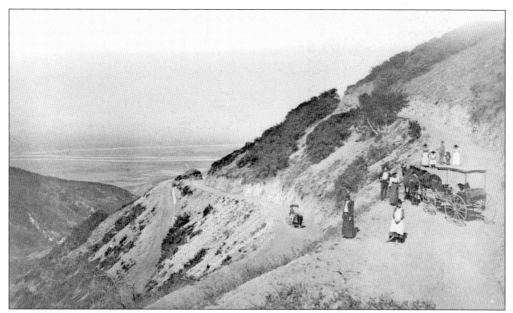

Only trails reached the mountains before 1852, when the Mormons built the first road up what is now known as Waterman Canyon, but the goldfields of Holcomb Valley, virgin timber, and an abundance of wild life and water sparked the move to build routes that could reach these areas quickly. This photograph shows the road built as an extension of Mormon Road, which became known as the Switchbacks.

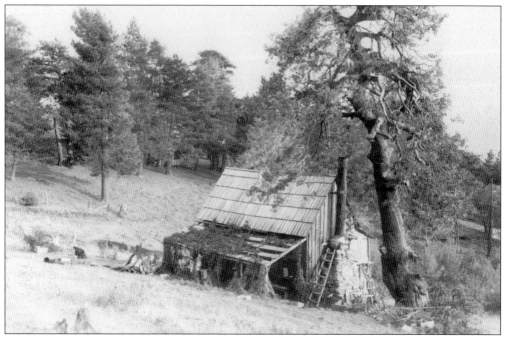

In 1880, the census taker could find only 64 people living in the San Bernardino Mountains. One of these was Fred Heaps, who built the cabin pictured here, and while he was considered a recluse, he welcomed visitors who happened along the trail to home-baked apple pie and some of his homemade brew.

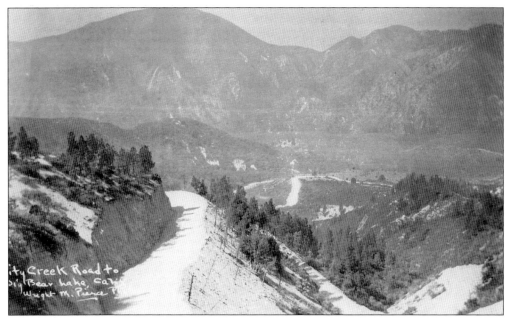

When David Seely signed a contract with James E. Danaher of Ludington, Michigan, on June 18, 1890, deeding his Long Point timber holdings over to him, Danaher envisioned a railroad running up City Creek to his sawmill on Pike Creek that would carry cut timber to his lumberyards in the California southland. This photograph shows his City Creek route headed up to the mill.

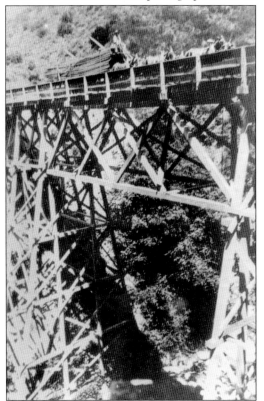

Danaher abandoned his plans for a mountain railroad because of the grade required for a steam engine locomotive and resorted to transporting cut lumber by wagons and teams of horses or mules. In this photograph, taken in 1892, a load of timber is headed to a box factory at Molino (now East Highlands) over the recently constructed City Creek Bridge.

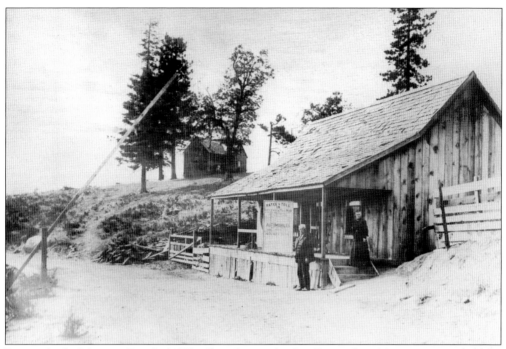

Except for the Mormon Road of 1852, all roads into the San Bernardino Mountains were built by private investments, and a toll was required to travel them as a means of paying back the investors. Pictured here are the tollgates at the Twin and City Creek Roads turnpike.

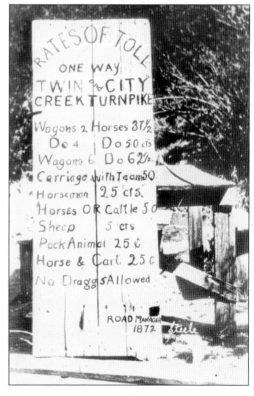

While viewers of this early photograph might be confused by the toll for a wagon and two horses, "37½¢," there actually was a one-half-cent coin at one time. The notice "No Draggs Allowed" refers to the practice of attaching the top of a tree or log behind a wagon and dragging it down steep slopes to act as a brake. This practice was not allowed because it damaged the road surface.

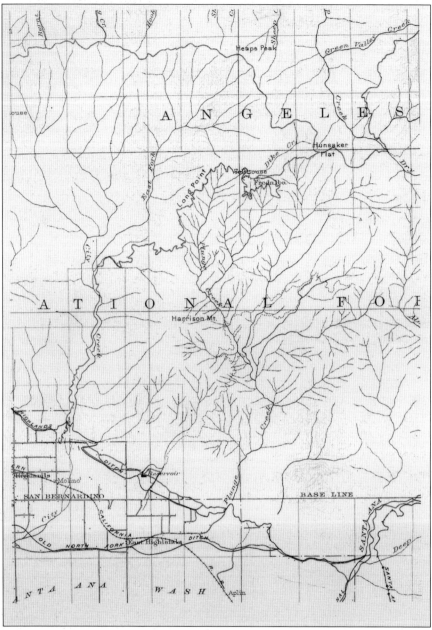

This topographical map from August 1901 is the result of an effort by the U.S. Geological Survey to map the entire nation. This project began in 1882, and by 1901, only 38 percent of the country had been mapped. The area in this map was part of the Angeles National Forest, which was created by Pres. Theodore Roosevelt on July 1, 1908, when he ordered that the then-San Gabriel and San Bernardino national forests be combined under one administration. However, in May 1925, due to the number of forest fires the plagued the areas, it was recommended that the forests be separated into different zones and the Cleveland, San Gabriel, and San Bernardino National Forests were organized under the administration of the Department of Agriculture. This map shows the Running Springs area by its original name, Hunsaker Flats. The road shown is the one built by Danaher. Note the tollhouse location.

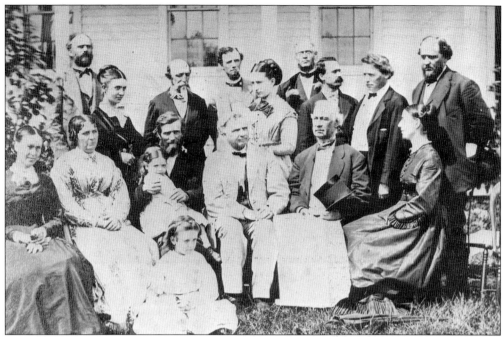

This 1869 photograph shows the "Founding Fathers of Ludington, Michigan," as they sign papers for the R&P Railroad. Identified are Patrick M. Danaher, lumberman (standing to the left), and James Danaher (standing fourth from left). The Danahers were to become major players in the development of the future Running Springs and the road that would take travelers there and to Big Bear.

At first, the Danaher brothers employed the hauling methods known to them, but oxen, powerful as they were, proved too slow in moving timber from the forests to the mill that would be built on Pike's Creek. It was not long before they began searching for a faster way to provide the mill with an ample supply of timber.

"Big wheels" were used extensively over level ground to haul cut timber to the mill. The log was attached to the underside of the wheel, and oxen moved ever so slowly to the mill site. The Danahers hoped to cut 60,000 board feet a day—about enough today to built two houses of approximately 1,500 square feet.

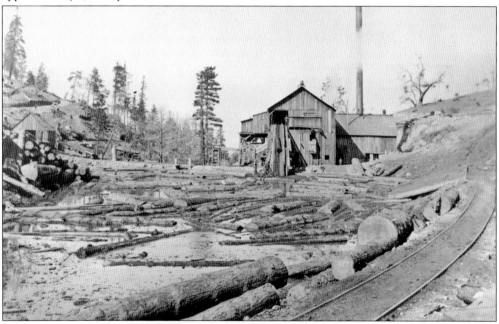

The Danaher mill, built on Pike's Creek, included a band saw operated by a 260-horsepower, steam-powered engine and a millpond to store and clean logs of material that might damage the saw blade. In this early photograph, the rails are in place for the newly purchased Shay steam engines, which would replace the oxen.

The Danahers soon discovered that lumber from their mill was of inferior quality when compared with the lumber coming from Oregon and Washington. It became known as "jack lumber" because it would warp so badly that one end of a board would bend and could meet the other end of the board halfway between its lengths. This could be overcome by curing the wood, and some houses in San Bernardino, Highland, and East Highlands still contain wood supplied by the mill. Because of the warping problem, however, a box factory was built on Boulder Street on a railroad siding called Molino (where Beaver Clinic is now located), and more money was found in making shipping boxes, crates, and trays for the booming citrus industry. The Danahers named their operation the Highlands Lumber (and Box) Company, but its new owners would later change the name. Messina, California, which appears on the bottom right of the advertisement, would also see a name change; in 1899, it was changed to Highland, not to be confused with East Highlands, as local residents are quick to remind people.

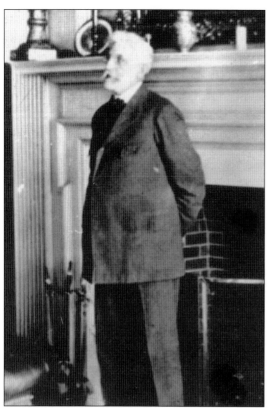

When the Danahers decided to sell their mill, the 1,600 acres at Long Point, the box factory, the toll road right-of-way, and other holdings—which included an additional 5,400 acres Danaher had leased from the U.S. Forest Service (USFS)—John E. Brookings asked his first cousin Robert S. Brookings (pictured here), founder of the Brookings Institution, for financial backing.

John E. Brookings had searched throughout the Southern states for timber holdings but instead found deadly snakes and malaria, which he contracted. He chose the dry, pleasant climate of the San Bernardinos and purchased this house in an upscale area of Redlands, California, where it still stands after more than 100 years.

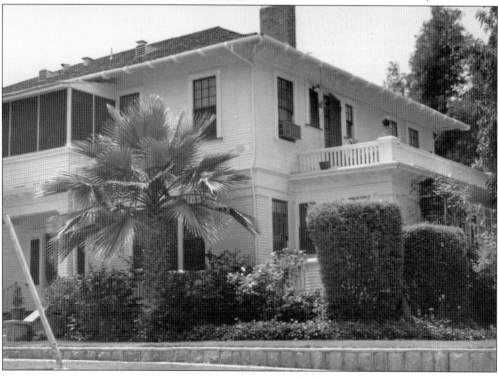

John E. Brookings, pictured here, was born in Keokuk, Iowa, in 1873 and died in 1950. It was on May 20, 1899, that he arranged to purchase the interests of the Highland Box and Lumber Company and organized the Brookings Lumber and Box Company. He was president, Robert S. Brookings was vice president, and his son Walter was secretary treasurer.

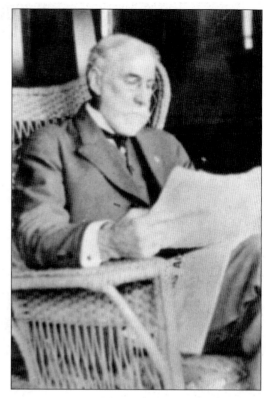

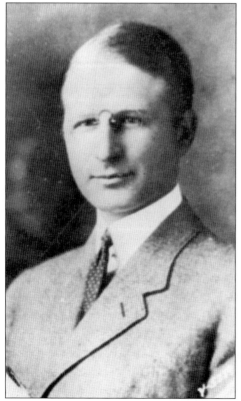

Walter DeBois Brookings, the son of John E. Brookings, not only became the secretary treasurer of the company but also continued on with the company when it moved to Oregon and joined the newly formed California and Oregon Lumber Company, which Brookings bought out in 1917.

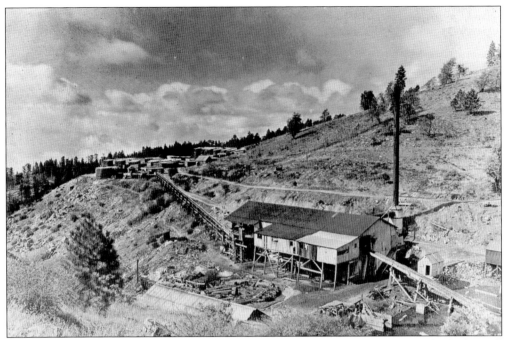

The Danaher brothers' mill burned October 13, 1906, and John E. Brookings rebuilt the mill pictured here on the burned site. The millpond is to the right of the mill, and logs were snaked up a conveyor system to the sawmill. Then cut lumber was moved up to the stacking area to the west of the mill, where teamsters loaded their wagons for the trip down the hill.

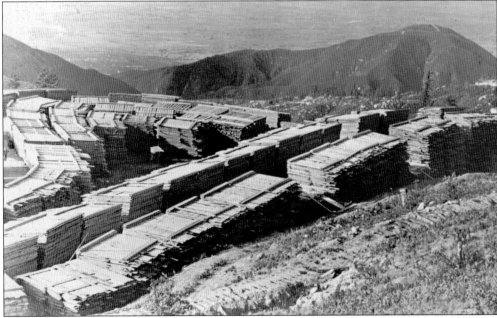

The cut lumber was stored in this area until it was moved by teamsters to the box factory in East Highlands. Several times, the entire storage area was destroyed by fires, which frequently burned the mountain slopes or, in some cases, were fanned by the high winds that blew sometimes from the south and other times from the north.

A community came with the sawmill, as well as many visitors and permanent residents living near the mill. Some were families of workers, and others were summer visitors who built cabins near the mill. A visit to the mill was a must for anyone who reached the area over one of the precarious and poorly graded roads into the mountains.

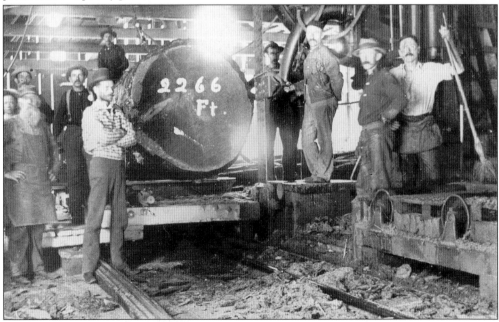

Inside the Brookings mill, a log is ready to be sawed by the giant band saw. The mill produced a great amount of sawdust, which was carted to the south of the mill. The resulting sawdust pile existed for many years and because of a heavy winter, actually slid down the east slope and up the west slope of Pike's Canyon in 1969.

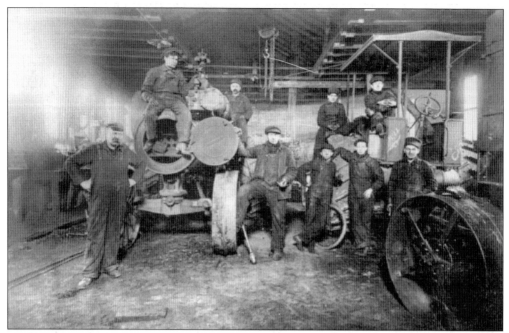

In this recently discovered photograph, the maintenance facility and mechanics working on steam-powered tractors can be seen. Most of the equipment purchased by the Brookingses had seen better days in other forests and required a great deal of care to keep the business going. A lot of "pirating" took place, and cast-off pieces of machinery can still be found along the rail beds.

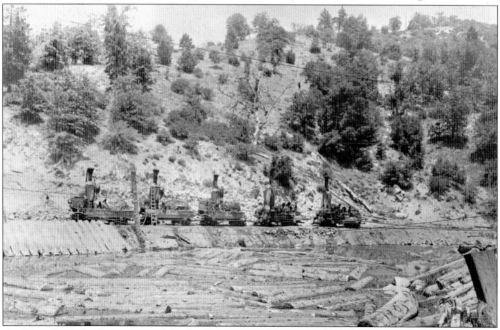

At the millpond, steam-powered donkey engines are being moved on flat cars to another location. The Brookings family only used six miles of narrow-gauge track, and this restricted their operations to that distance from the mill. When one area was cut, they would pull up the usable track and run it to another area, moving the Dolbeer donkey engines along with it.

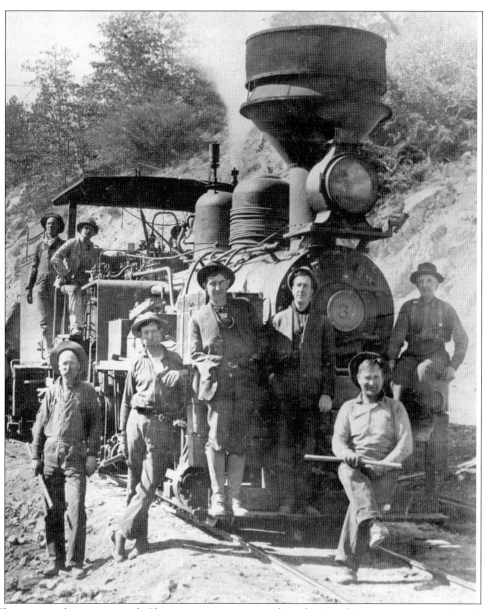

There were three two-truck Shay steam engines used in the Brookings operation in the San Bernardino Mountains. These engines were purchased from other logging companies and were the preferred engine for this type of work. They were designed and built by Ephraim Shay, who envisioned a steam engine adapted for maximum traction and power. His vertical engine, with a shaft geared to each axle and driving gears attached to the outside of the wheel on each axle, caused each truck (driving wheel) to turn independently, placing the entire weight of the locomotive on the driving wheels. The No. 3 Shay pictured here was Engine No. 808, built in August 1904 and purchased by the Brookings in 1905. The engineer was Mr. Tinsey. Pictured first row, fourth from the left is the legendary Squint Worthington, who only had one arm but was a dead shot with a rifle and owned a ranch north of Lake Arrowhead that still bears his name. Another legendary figure, seated to the far right, is George Tillitt, who was the tollhouse operator in Green Valley.

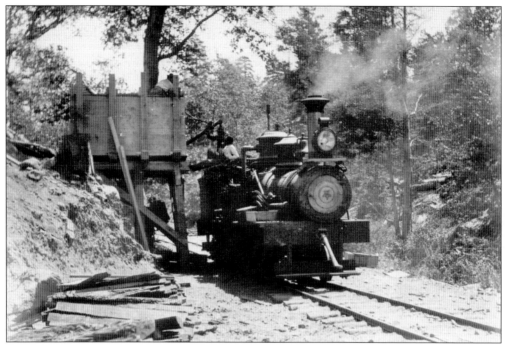

A second Shay is seen in this photograph just east of the mill filling the boiler with water. This is the "Star Shay," which carried this name for the obvious fact that it had a star on its front. This is believed to be the last Shay to survive from the Brookings operation in the San Bernardino Mountains.

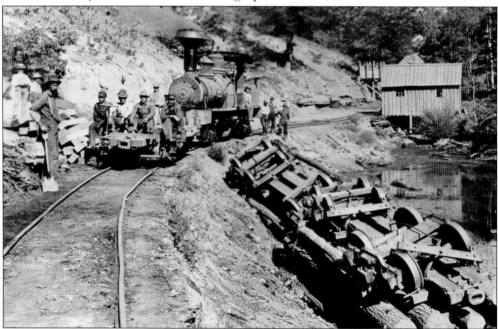

"John Gormley on one occasion let the train get away from him and it ran up and down for three days before they could stop it," reported Harry Welton in his weekly column in a Highland newspaper. As seen here, a derailment caused by an out-of-alignment track toppled the flatcars loaded with logs into the millpond.

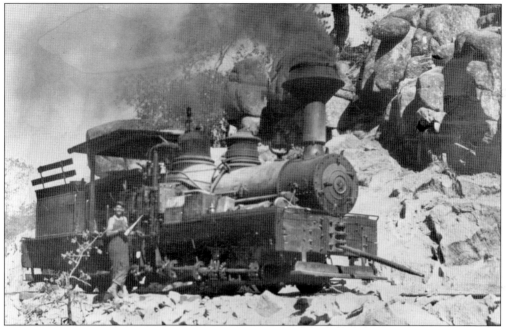

Near the Dry Creek area, the Star Shay and its engineer can be seen heading into the forest to bring loaded flatcars to the mill. The Brookings operation was considered small when compared with the giant mills that existed in Oregon and Washington. For instance, while only six miles of track existed in the San Bernardinos, the Simon Benson Mill on the Columbia River operated on 75 miles of track.

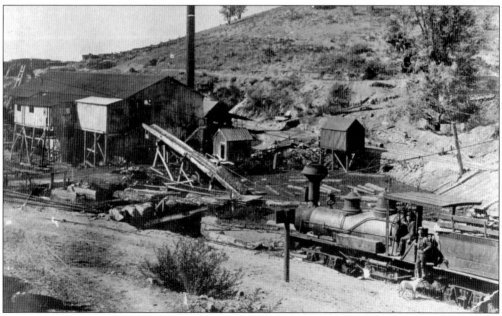

The third engine owned by the Brookings Lumber and Box Company was another two-truck Shay, No. 154 of the Lima class, built in 1886. There is some speculation that there were actually only two Shays operating at the Brookings mill and that the third one was really the Shay Star, or No. 3, after it had been stripped of its identifying markings.

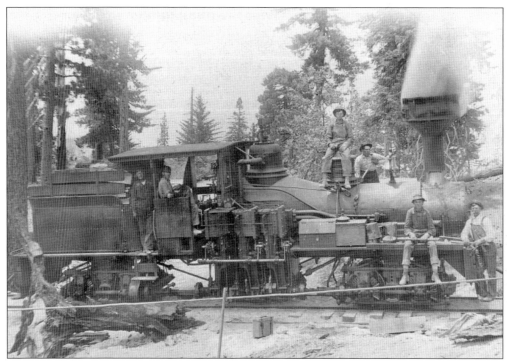

Clearly visible in this photograph is the distinctive design of the Shay steam engine: driving gears mounted on the right side of the locomotive. The club held by one of the workers was used for leverage while applying the brakes. Fog was often a major problem, making it difficult to stop a Shay on a downhill grade.

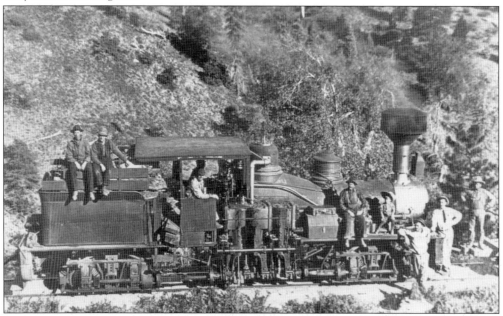

One of the pleasures in visiting the mountains was to catch a ride on one of the Shays. With no amusement parks, movies, or electronics available, people found their own entertainment, and a trip to Green Valley to this young boy and a well-dressed tourist was surely an experience to remember.

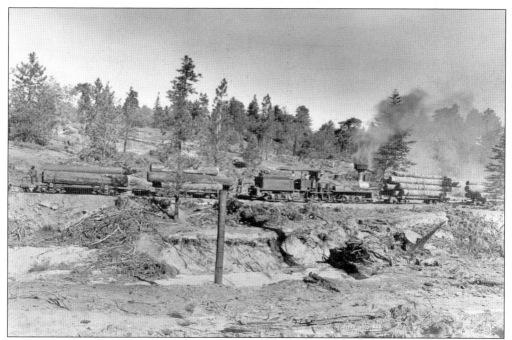

While the Brookings mill eventually reached its goal of 60,000 board feet per day, the market for lumber products was weak. Also, the mill did not approach the output of the bigger mills in the Pacific Northwest. For example, a Weyerhaeuser mill in Washington produced 39 million board feet per day in 1905. Nevertheless, the Shay engines continued to bring in fallen timber to the mill as John Brookings began to search for new territory.

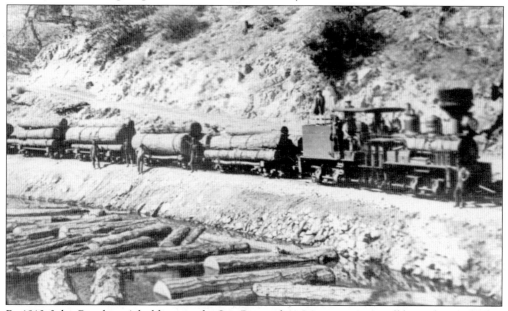

By 1913, John Brookings's holdings in the San Bernardino Mountains were all but exhausted. This photograph, taken about that time, shows some of the last logs to reach the millpond. Conditions in Europe were changing, and World War I would seriously affect lumbering throughout the United States.

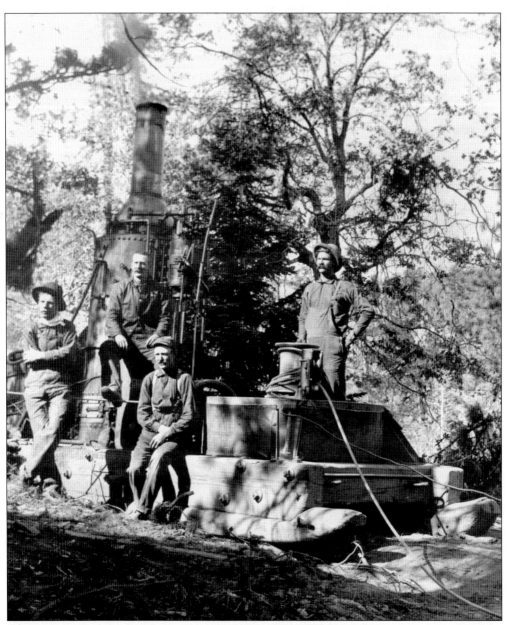

A turning point in lumbering history occurred in 1880, when a move was made throughout the industry to retire the use of animals for hauling cut timber in favor of mechanization. John Dolbeer took a steam engine of his design and produced what would become known as the "steam logging machine" and later the "donkey engine." It first appeared in 1881 in Northern California. Dolbeer was himself a logger and owner of a mill and knew what worked in the forests and what did not. Pictured here is one of his Dolbeer steam-powered donkey engines, owned by Brookings mill, and the crew it required for operation. The "choker setter" worked at a distance from the engine by placing a rope (cable was used later) around the log to be brought to a loading area. The "donkey puncher" tended to the engine itself. The job of the "spool tender" was to keep the rope (cable) on the spinning spool. A "whistle punk" was usually a young boy who signaled to the donkey puncher that the line was attached to the fallen log. He would also set the spool to spinning.

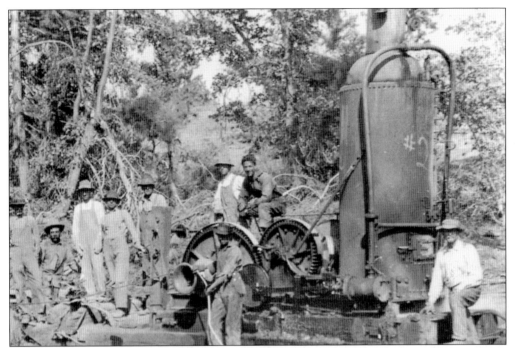

Some Dolbeer donkey engines were of a grand scale, as the one shown here. The spool tender is ready for a signal from the whistle punk that a log is ready to be pulled in, but not until they all stop to have a photograph taken.

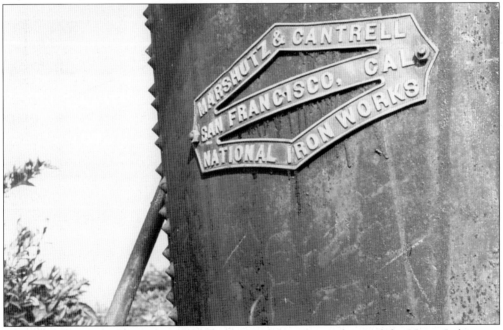

In 1975, Burton Denton and his brother Frank, longtime residents of the Hume Lake area, salvaged a Dolbeer engine from Windy Gulch near Hume Lake, California, and restored it to full use. The Hume-Bennett Sawmill, which burned in 1917, used these engines, and Jim Sims, who photographed the nameplate on this one, documented their history.

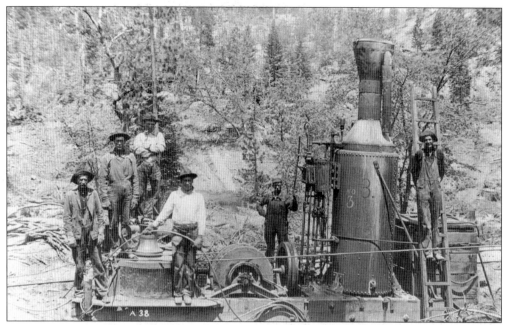

The crew of Donkey Engine No. 3 pauses for a photograph, and the spool tender stands ready. Besides the four crew members used to operate the engine, one more hand was required—or better yet, four hoofs—as a horse was needed to carry the cable from the engine to the log for the choker setter to tie to the fallen tree.

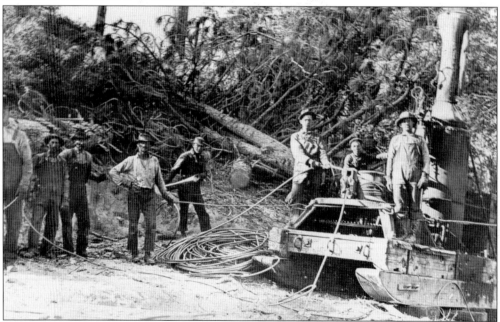

The budget for cable must have been tremendous and, as one walks the remaining rail beds, one can still find cable where it had been discarded or hooked into trees where donkey engines were anchored. The cable was also very dangerous, and on at least one occasion, it caused the death of a choker setter when a log snagged, and the cable broke, whirled across the terrain like a broken rubber band, and struck the unfortunate man.

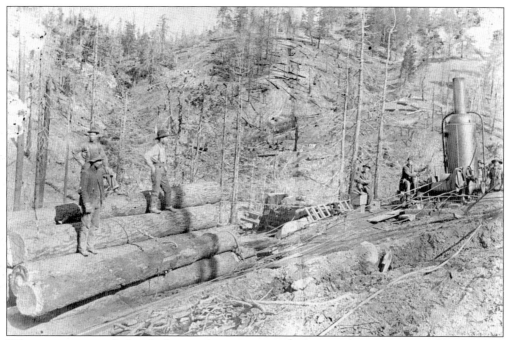

What trees remained after the best timber was cut were often victims of fires started by the Shay steam engines and the donkey engines, which both ran without spark arresters until the USFS required their installation. This photograph shows what remained after a forest was cut and burned, leaving an almost denuded hillside.

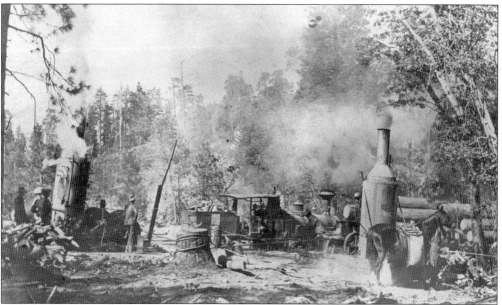

Here two donkey engines work side by side. A Shay engine and a horse stand ready to drag the cable out to the next log to be hauled in and loaded onto the flatcars behind the Shay. Falling trees, the sound of steam whistles blowing, the rumble of the Shay engines, and the not-too-distant blasting of tunnels being built to carry water to the Little Bear reservoir under construction to the west must have echoed across the mountain.

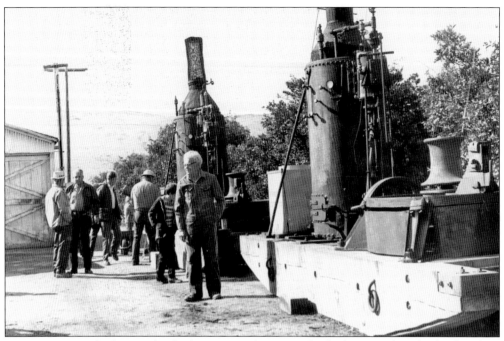

Burton Denton stands near the donkey engines he restored, which are ready to be fired up for a demonstration. After a year of finding parts (he found the boiler tubes, gears, and cylinders in good condition) and after removing caked grease and rust, he and his brother fitted both engines back together. These engines are now on display at the Hume Lake ranger station.

When parts wore out, they were cast aside in the forest. Parts of donkey engines can still be found along the rail beds. This representative piece is located at the Big Bear museum. Workers carved their initials into the hard metal, and grooves are visible where the cable cut a path after many hours of use.

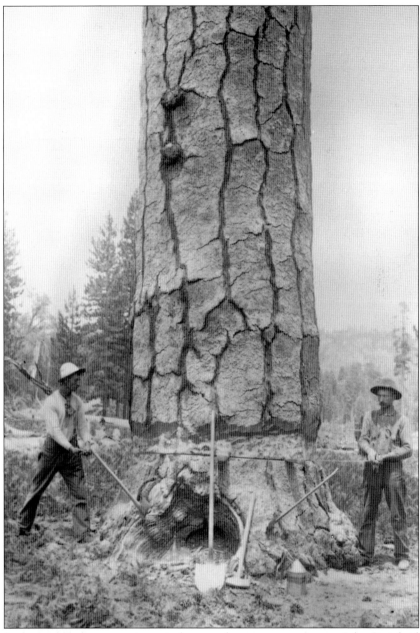

"To look at mountains—mountains, mind you, and great trees . . . " wrote John Steinbeck in *The Grapes of Wrath*. The Joad family of his famous book looked forward to going to California from their drought-stricken and wind-blown lands in Oklahoma, if for nothing else than to be able to pick an orange from a tree, taste its freshness, and quench their thirst. And it was the "great trees" they had heard about that drew them westward to an imagined better life. Here, in this photograph, tree fallers begin to bring down one of the great trees that had stood for perhaps 500 years. This giant ponderosa (also called the western yellow pine) would produce enough lumber to build a small residence or would provide "shook" for hundreds of citrus packing boxes. Some ponderosas reached 165 feet with a diameter of four feet and would take anywhere from a half hour to two hours to fall.

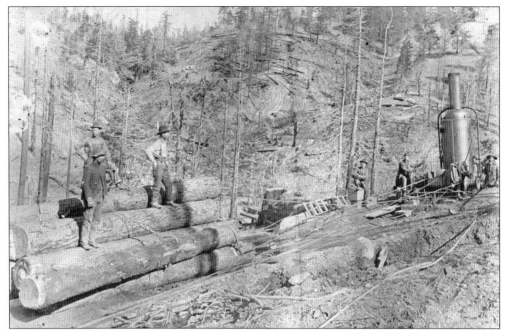

The Brookings lumberjacks worked an 11-hour day six days a week and were paid $1.75 for a day's work. Sundays were strictly observed as a day of rest, the result of their religious upbringing. When winter came, most went down to the milder climate of the valley and found work there, possibly returning to the mill as soon as the snows subsided.

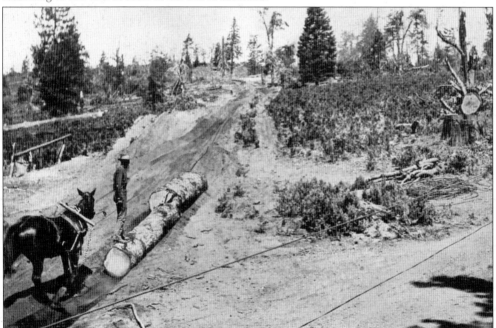

As this photograph shows, all trees that could supply lumber were cut, and only cedar and oak remained standing. Besides the ponderosa, the San Bernardinos had great stands of Douglas fir, hemlock, and sugar pines. Because this forest had never been lumbered, all these trees were original growth.

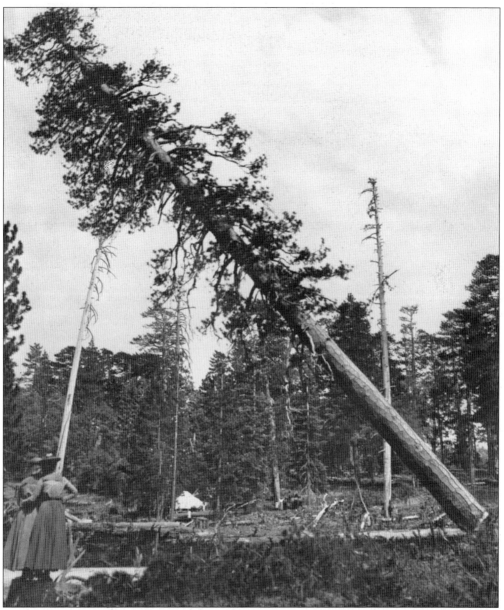

Besides riding a Shay engine or a visit to the sawmill, visiting one of the camps and watching the fallers bring down a giant ponderosa was a main attraction that even the ladies enjoyed. The sound of a crashing 150-foot tree striking the earth and sending vibrations across the terrain was something to tell the folks about back home. There were seven camps, each numbered, throughout the Brookings holdings (note the tent in the background), and all were connected by rails. While the workers were only a few miles from the mill, most stayed in the camps where tent houses and meals were served each working day. Not all were content with the working conditions, and in 1907, a strike was called to shorten the time spent in the forest from 11 hours to 10 hours. John Brookings, rather than meet the demand of the workers, paid them all off and hired new crews.

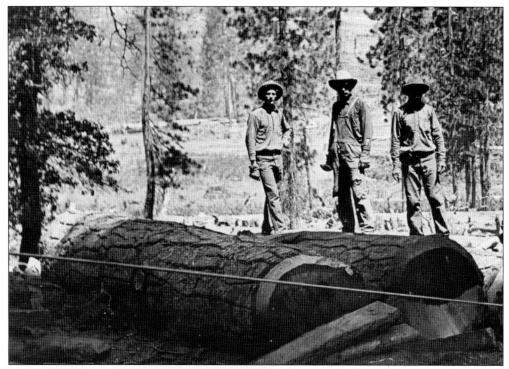

After a tree was felled, a "bucker" cut the tree into lengths of 24 feet to 32 feet so that it could be lifted by a steam-powered donkey engine onto a flat car and transported to the mill site. Note the cut at the end of the log—a strait cut with a saw—and the absence of ax marks, except to mark the point the log was to be sawed and to remove bark.

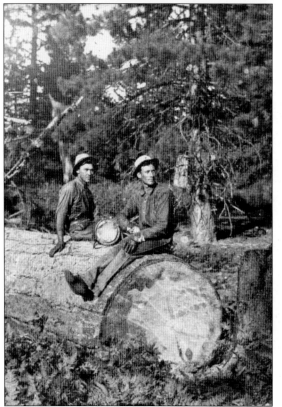

There was always time for a Kodak photograph. Several photographers came to the logging camps to record the only logging operation in the San Bernardino Mountains that operated on the scale that the Brookings did. While these men suffered a great deal from injuries and from sore and pulled muscles, the single greatest ailment that plagued almost all of them, for lack of dental care, was toothaches.

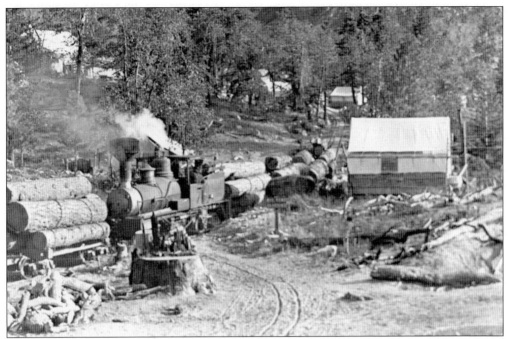

Here a Shay locomotive passes through Camp No. 7 (now the location of the Calvary Chapel camp) near Green Valley. This was the last camp operated by the Brookings Lumber and Box Company and was located in a beautiful meadow that the Native Americans used, as evidenced by the numerous grinding holes found on the property.

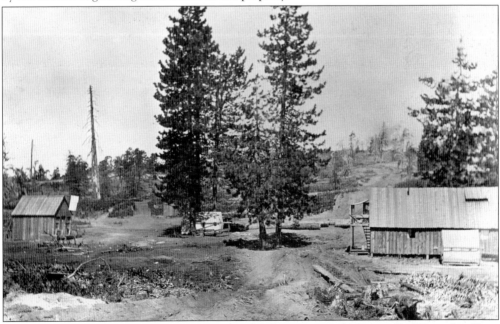

This photograph, taken about 1900, appears to be the camp at what was called Hunsaker Flats, now the location of the town of Running Springs. It is unusual that a few trees were left standing, but some forest preservationists living at that time were able to influence the lumbermen to save some trees in inhabited locations.

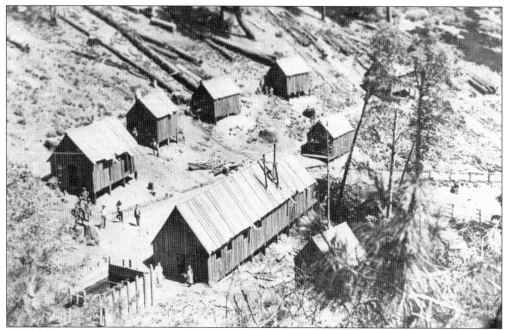

The cabins pictured here were located east of the mill and housed a commissary and living quarters for the mill workers, who in some cases brought their families with them. A trip up or down the hill would take most of the day by wagon, but visiting a relative at the mill for a day or two or staying through the working days with a husband was always a possibility.

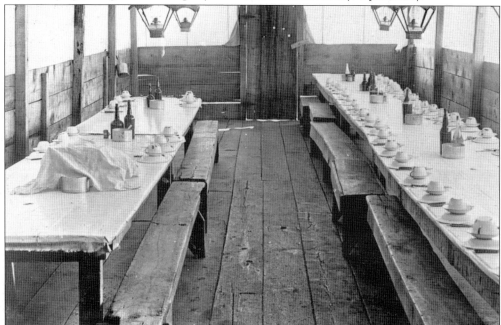

The lumberjacks, engineers, and other workers ate well. Chinese cooks were hired to provide the types of meals that lumberjacks expected. There was lots of meat, potatoes, coffee, and apple pie for dessert. This mess hall was located at Camp No. 7, and the lamps in the photograph bring a hefty price as collectibles. Occasionally they can be found at one of the campsites.

Robert MacColl, as a young boy, lived at various camps with his mother, sister, and father, who was in charge of the commissary. MacColl returned in his later years to Camp No. 7 with his dog Gretchen and found the spot where his family lived in a tent house (wooden foundation with a canvas top) and the tree where his father had hung a swing.

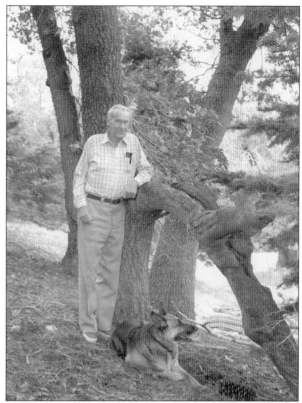

In this photograph, taken in 1913, the MacColl family—Jennie, age 13; Robert, age eight; and their mother, Marie Haberecht MacColl—pose before their tent house at Camp No. 7. These impressionable years remained some of the happiest and best remembered of the MacColl children. Even though 75 years had passed, they could remember their pleasant days there "almost as if it were yesterday."

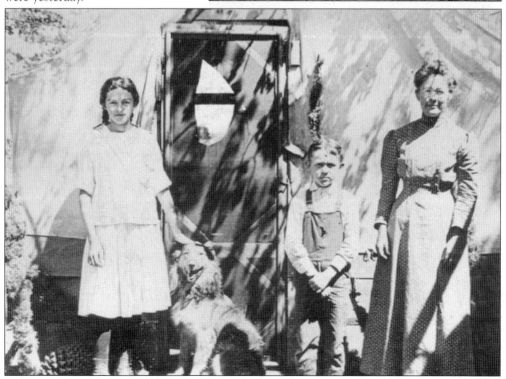

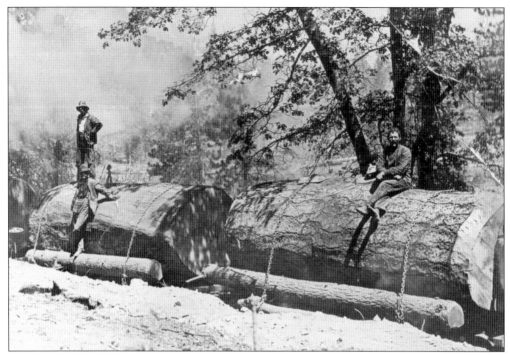

In this photograph, the workers are atop some of the biggest logs taken from the virgin-timber stands in the San Bernardinos. Most stands of timber in the mountain today are second growth, and only an area known as Seymour Flats preserves trees that have never been harvested.

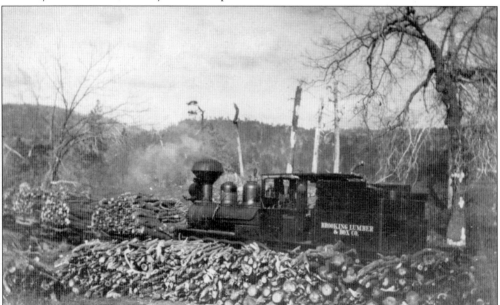

Here a Shay engines carries a load of firewood used to fire the steam engines. The whistle punk on a donkey engine was also the "water punk" and kept the boiler fired up and supplied with water. Probably the most famous of the Dolbeer punks, before he became a reporter, was investigative journalist Edward R. Morrow. Note the absence of an "s" on Brookings, the result of a non-attentive lettering artist.

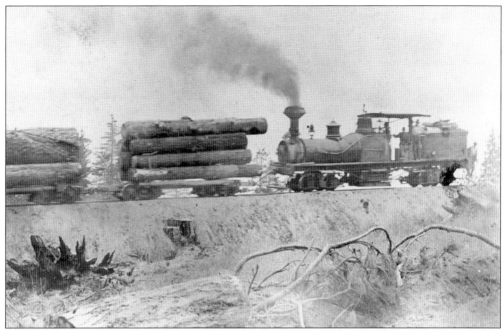

Many of the roadbeds built to carry the Shay engines to and from the mill still exist, and few travelers who cross the Rim of the World Highway between Heap's Peak and Green Valley Lake realize they are following the same route established by the Brookings enterprise. Nor did the engineer on this engine realize that someday thousands of automobiles would be driving this same road.

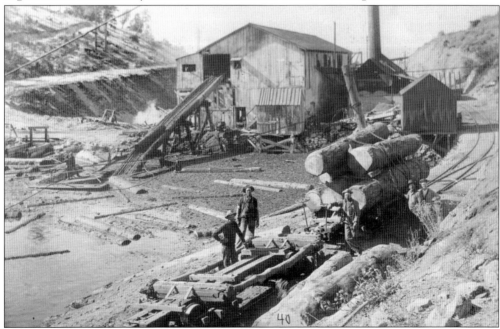

This photograph of the Brookings mill gives a good view of the layout of the millpond, unloading area, and road to the sawdust pile (to the left). There is little evidence of there ever having been a sawmill in this area today. It is on private property, and what little remains is covered in dense brush.

A good soaking in the millpond removed unwanted material from the logs, and a "pond monkey" would use a cant hook to float the logs to the conveyor belt, where one by one, they would be moved into position to be cut. About 60 percent of the cut timber went to the box factory in Molino, and the remainder was sent to lumberyards Brookings owned.

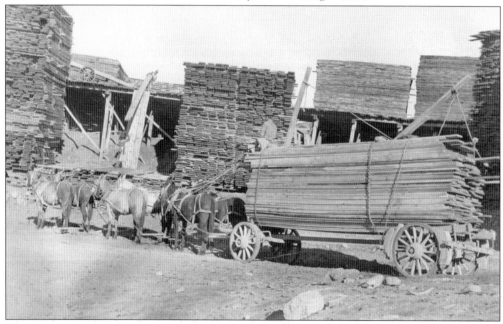

Teamsters arrived early in the morning on the hill and loaded their wagons for the trip down. They were paid by the load and were always competing with the other teamsters to see who could carry the most in one trip. At first they were independent and provided their own teams of horses or mules but later disputes would change their circumstances.

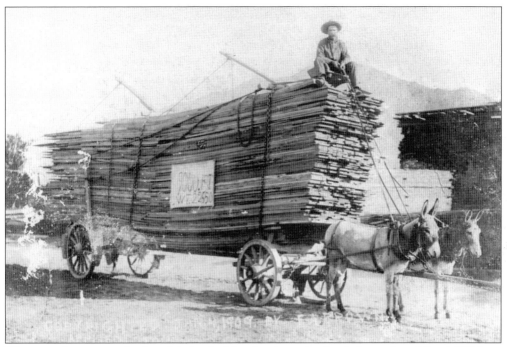

This proud teamster displays his load of lumber brought down from the mill—9,000 feet, weighing 22,550 pounds. Since the road down the hill had little or no uphill grade, he only had to worry about a runaway team or wagon, which could easily be lost over the sometimes dangerous and sharp curves.

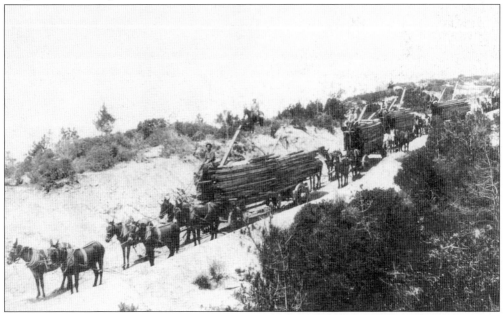

Teamsters would leave the box factory in Molino between 3:00 and 4:00 a.m., reach the mill by 6:00 or 7:00 a.m., spend several hours loading their wagons, and arrive back at the box factory about 3:00 or 4:00 in the afternoon. Some slept on the way down and let their teams find their way back.

43

E. G. Boardman, seen here with his wife, was hired to drive for Brookings when he was quite young. However, he lost a leg when he jumped from a loaded wagon returning to the mill to pick up the "ribbons," or reins, which had slipped from his hands. The wagon bumped against something, Boardman fell between the hub of the wheel, and his leg became entangled so badly that it had to be amputated.

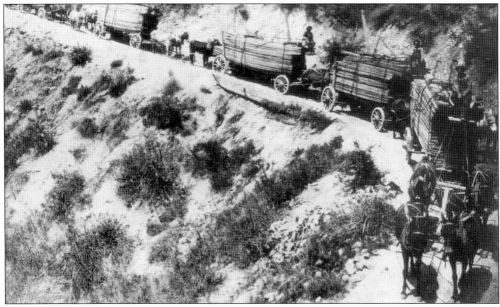

Guadalupe Hill was a point on the road that claimed many wagons, as well as their loads and teams. Sometimes a mule team would slip and take everything down with them. This was the case in January 1900, when a mule was pushed over the edge and the driver jumped from the wagon and released the other mules but lost his wagon and load—and more than a day's pay.

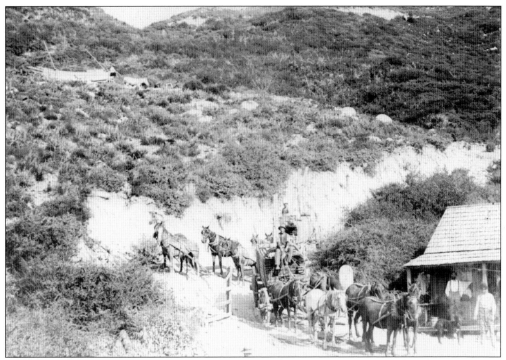

Teamsters and their wagons can be seen coming to the tollhouse (see map on page 14) on their way down to the box factory. Most teamsters owned their own wagons and teams and worked in the citrus industry when things were slow at the mill. Some, such as E. G. Boardman, who was hired as an accountant after his accident, went to Oregon when the mill closed.

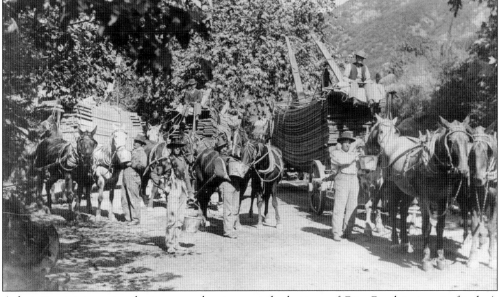

A favorite stop to water the teams and rest was at the bottom of City Creek just east of today's Highway 330. This pleasant spot had natural springs and running water throughout the year, and it continued to exist until the highway was widened, the trees were removed, and the water was diverted.

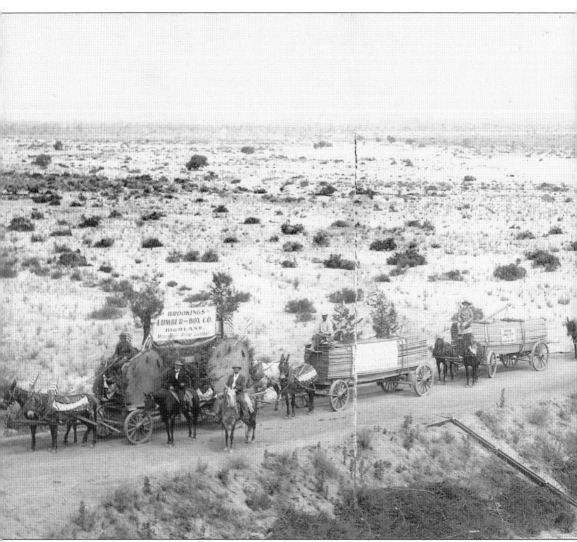

This photograph was taken at the crossing of the Santa Ana River, which is now Boulder Avenue, which connects Highland and Redlands, California. It was taken on July 4, 1902 (compare this photograph to the lower photograph on page 48). It was sent to the author by the caregiver of Florence Montgomery, a relative of the Brookings family, soon after she died. The caregiver sent

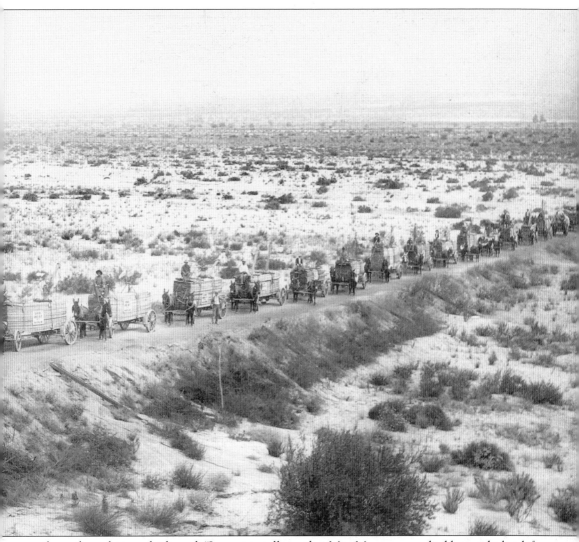

the author a letter, which read, "I regret to tell you that Mrs. Montgomery died last night but left some photographs on the table for you. Do you still want them?" Montgomery had visited the mill many times as a child and was living in Southern California at the time of her death.

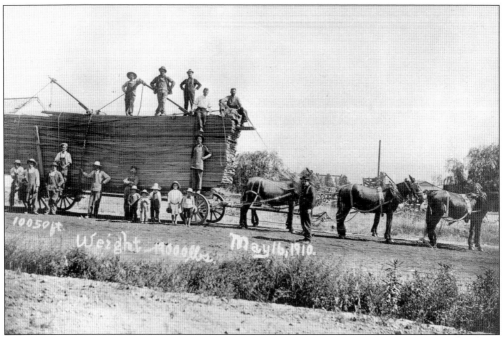

It was almost always profitable to bring down as much lumber as a wagon and team could handle. But in one case, at least, it was not. Teamster Luis Salcido hauled 7,800 feet in one load, a record at that time. He was paid $22.50 but broke two wheels before he reached the box factory and had to spend most of his day's earnings on repairs.

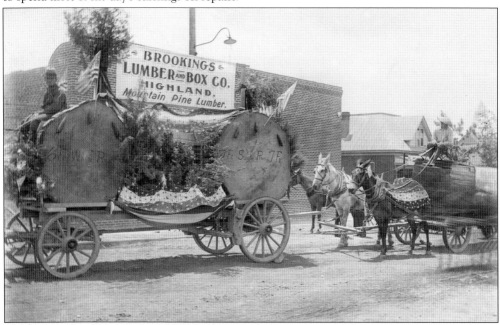

This Fourth of July parade in 1902 (see page 46) displayed the workings of the Brookings mill and teamsters. The lettering on the log reads, "7 ft sugar pine." Parades were always a big event, and Luis Salcido again tried to set a new record by loading his wagon with 9,300 feet in an industrial parade in San Bernardino on May 19, 1909. No breakdowns were recorded.

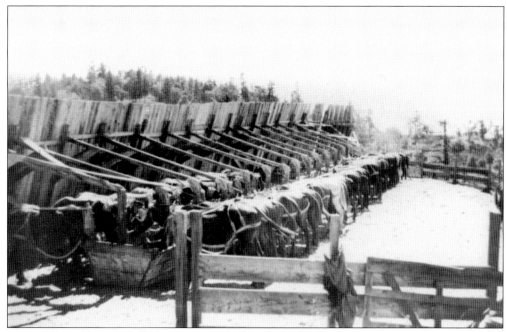

After the trip down the hill, the teams were fed and rested at the box factory. Brookings paid a flat rate of $2.50 to teamsters plus compensation for the amount of lumber they brought to the mill. The teamsters went on strike in 1907 for a 50¢ raise per thousand board beet. Brookings fired all of them and went to Merced and Bakersfield, where he purchased his own mule teams.

The box factory was one of the major employers of the work force in Highland and East Highlands, and as the citrus industry increased the shipments of their produce to eastern markets, the need for shipping boxes also increased. The box factory provided the citrus owners with "shook," the slats that were quickly made into boxes. The citrus produce was then packed, iced, loaded onto freight cars, and shipped to the eastern states.

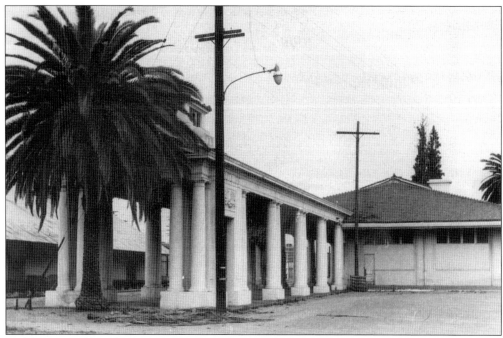

Brookings contributed in many ways, not only to the development of Running Springs, Arrowbear, and Green Valley Lakes, but also to the communities in the valley below. It supplied lumber for many of the houses, bridges, and public buildings, as well as for the Redlands railroad station pictured here. The columns seen here were cast from the lumber Brookings supplied to the builder and the building. While no longer used as a railroad station, it is a local historical landmark.

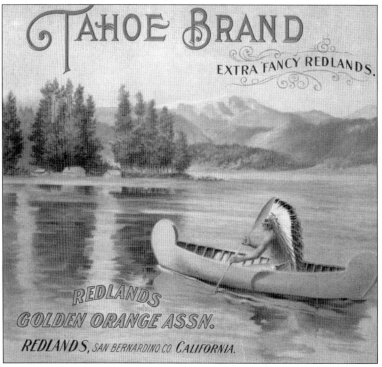

Who would have known in 1895 that someday collecting orange boxes and their labels would become a hobby? Today these labels bring prices that would astound the workers of the Brookings box factory. Pictured here is the label of the Redlands Golden Orange Association, the Tahoe Brand "Extra Fancy Redlands."

In the Pratt, North, and Seymour Mill Company in Redlands, elaborate Victorian woodcut styles and bargeboard decorations for aristocratic and upper-middle class homes were created from lumber supplied them from the Brookings mill. This building stood for 101 years until it was demolished for the Albertson's market complex in 1987. Louis Fletcher owned the mill and invented the Hustler Carr Press, which turned lumber into orange-packing boxes.

On top of the hill, people went about their own lives. Brookings paid his teamsters to haul lumber down the hill and return with supplies for the commissary. Locals could purchase just about anything they needed, and a special order would be filled by the next day. Not only did the mill workers utilize the commissary, residents of Fredalba, Smiley Park, and Hunsaker Flats (later Running Springs) made purchases here.

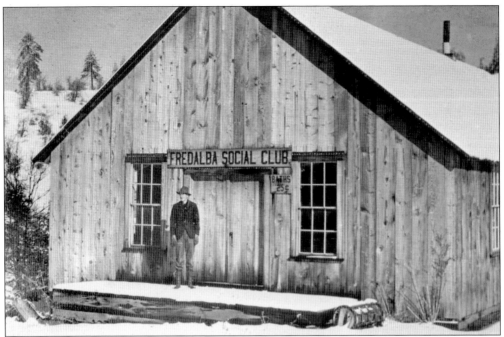

Life was not dull, by any means, at the mill site. There was a social "club," where there was a piano (Jennie MacColl practiced here), and there were dances for the mill workers and lumberjacks, who came in hobbed-nailed boots and cleaned up as best they could. The music was supplied by a fiddler and any other musician who happened to come along with his instrument.

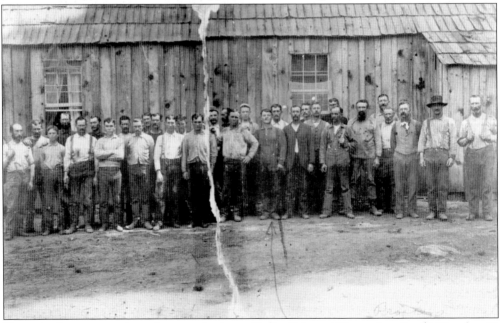

Here are the strong and sturdy men who kept the Brookings mill running. For $1.75 a day, 11 hours a day, they risked their lives. They would give it up within seven years, due to the physical stress. They knew the dangers of falling a 100-foot tree, and when one snagged, they saw it as a potential "widow maker."

Mail came daily to the post office (except Sundays), and a penny postcard then still cost a penny. The post office first opened in April 1892 under the name of Danaher Post Office, and in 1896, the name was changed to Fredalba Post Office. It remained open intermittently until 1924, when it ceased to exist. Today a collector will pay a $150 or more for an envelope or postcard with the Danaher or Fredalba seal.

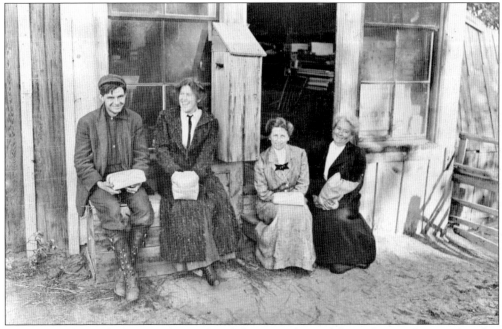

Waiting for the mail, these residents of Fredalba or Smiley Park have their packages in hand to send down the hill to friends or relatives. One can only guess what they may have in the packages. These communities met all the requirements of the people who lived there, and many spent a good part of the year working at the mill, in the forest, or vacationing.

Yes, there was a school. In fact, this building remains today, not as a school but as a private residence. Where there are families, there are children, and where there are children, there is need of a teacher. The people of Smiley Park and Fredalba brought them all together in this one-room schoolhouse, where learning took place throughout the year.

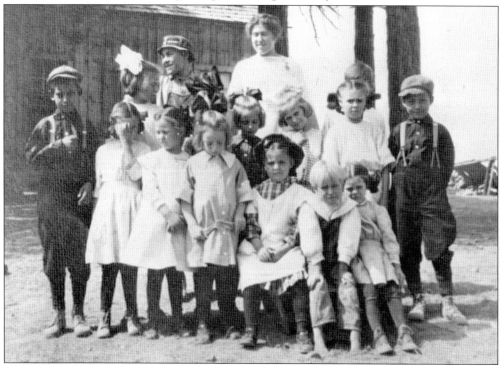

G. Athel Seymour was the teacher, and she was an expert in teaching grades kindergarten through—well, whoever showed up. This happy group got a first-rate learning experience living in a mill town, as nature was all around them as well as a big industry. Students didn't even have to wear shoes to school (see student front row right).

The women pictured here are enjoying a croquet match. During the spring and summer months, the mountain visitors found many outdoor recreational activities. Just a hike into the woods or down to Deep Creek to fish, hunt, or go for a swim in the cool, fresh water that flowed from the melting snow slopes was an adventure.

It has been said that Mrs. Brookings was a conservationist in the real sense of the word and told her husband that she wanted this plot of land to remain uncut. As of today, it has never been logged. The trees that have survived fires, drought, and lumbering still exist in this beautiful meadow south of Running Springs. Unfortunately, it is on private land and there is no public access.

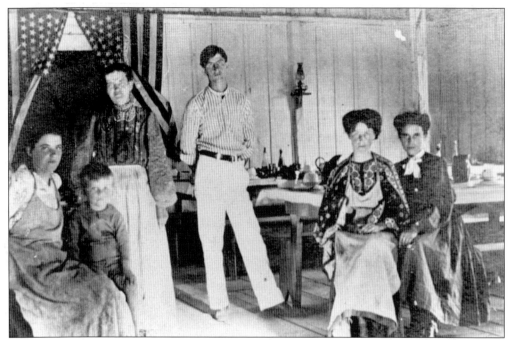

Here, at the social club, a group of locals gather to prepare for an evening of dancing, fiddle playing, good food, and socialization. What better way to celebrate the Fourth of July? Robert MacColl remembers that he and others used to walk the "government trail" from San Bernardino to the top of the mountain just to attend these celebrations.

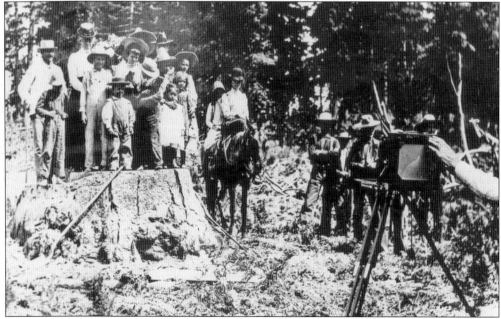

Several photographers visited the mountain communities and sawmill, but unfortunately, most of their work has disappeared. Here a photographer is being photographed by another photographer, who records on glass plates anyone and everyone within reach of his lenses. Many of these rich historical photographs have been disposed of by descendants who never realized their value.

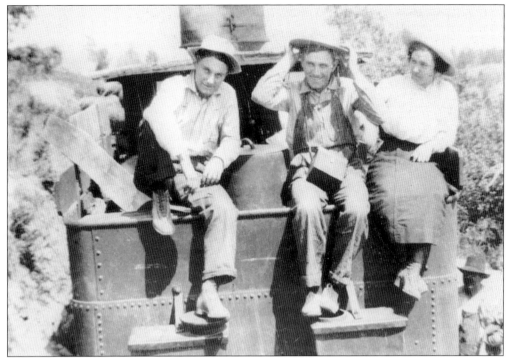

The Tillitts—Mort, Bert, and his wife, Mabel Horton Tillitt—catch a ride on Shay No. 3 to Green Valley (before the lake came into existence), where they operated the tollhouse to the Snow Slide Road, the only way to Big Bear Valley from the west in those days. Travelers along this road entered the valley at Fawnskin.

This photograph from 1899 shows John E. Brookings, second from left, hunting with friends. At the time, mountain wildlife consisted of bighorn sheep, raccoons, squirrels, deer, coyotes, grey foxes, bobcats, raccoons, ringtailed cats, prong-horned antelope (extinct), kit foxes (extinct), the California grizzly bear (extinct after 1906), and mountain lions weighing as much as 165 pounds and measuring up to eight-feet long.

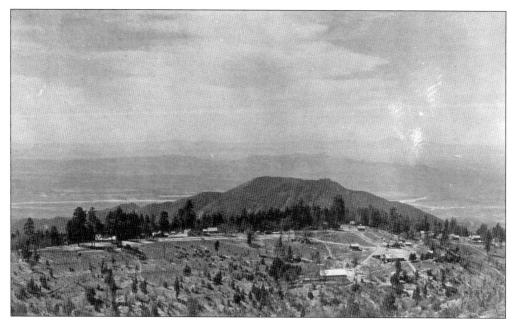

This photograph, taken before 1900, looks to the southwest across Smiley Park and Fredalba and toward what is the city of San Bernardino. The Santa Ana River is visible in the valley below. The community of Fredalba is in the foreground, and the commissary and social hall are in the lower portion of the photograph. The house to the far left remains as one of the original buildings.

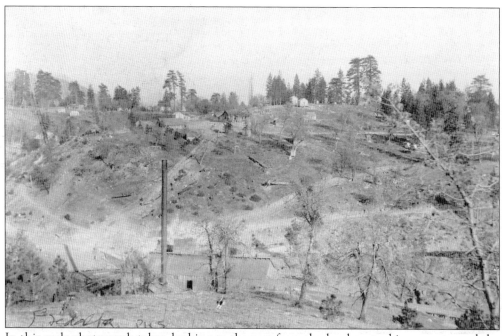

In this early photograph taken looking to the east from the lumber-stacking area toward the community of Fredalba, one can see that, except for the private properties on the top of the hill, the mountain slopes were clear cut with no trees remaining. The mill can be seen in the foreground.

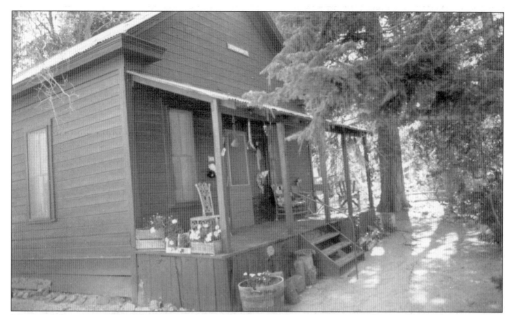

Many of the original buildings constructed by families from San Bernardino and Redlands remain today in the communities of Fredalba and Smiley Park. Most of them belong to the families that built them, having been passed on from one generation to the next. These cabins are museum themselves and display the workmanship of those days in their exterior and interior construction.

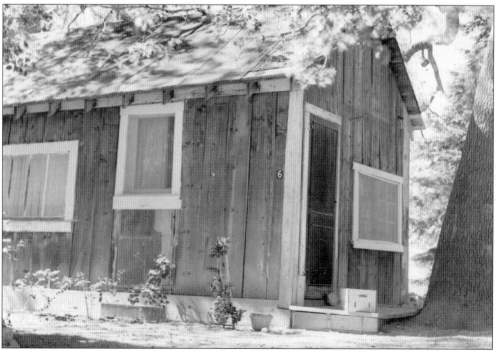

This small cabin was built to house mill workers and was only recently razed by the owner. The wood used to build this cabin came from the mill, and the band-saw marks were clearly visible. The wood had hardened over the years, and an attempt to drive a nail into it would cause the nail to bend.

Jim and Mary Baugh, residents of Fredalba, converted this lumberjack's living quarters into a tool shed. When the mill was in operation, six men lived in this 6-by-12-foot cabin, with three on each side in bunk beds. A little crowded perhaps, but easier to heat during the colder months. No meals were fixed here since they would eat at the cookhouse.

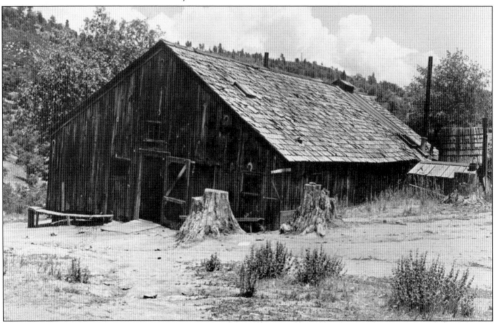

This was the cookhouse, where meals were served to the mill workers, teamsters, and lumberjacks. While the building no longer stands, debris still is visible behind what would have been the rear of the building. Rusting cans, meat bones, broken dishes and cups, and other items scattered about give evidence of the trash pile created by the cooks.

Highland, Cal., Nov. 25, 1904.

BROOKINGS LUMBER AND BOX COMPANY

SUGAR PINE, YELLOW PINE
WHITE PINE, SILVER FIR
CEDAR, OREGON PINE AND
REDWOOD LUMBER
SHINGLES, LATH, SASH AND
DOORS, PINE BOXES
MILL WORK, ETC., ETC.

MANUFACTURERS

WHOLESALE AND RETAIL DEALERS

TELEPHONE MAIN 111

SAW MILL AT FREDALBA
PLANING MILL
BOX FACTORY, WHOLESAL
YARDS AND GENERAL
OFFICE AT MOLINO
POSTOFFICE ADDRESS
HIGHLAND, CALIFORNIA.

SOLD TO E. E. Barnes,

Highland, Cal.

ORDER NO. 5854

NO. PIECES	DIMENSIONS AND GRADE	FEET	TOTAL FT.	PRICE	AMOUNT
1	#1 Std. White Pine, S2S	11'			
5	1 x 8 x 16	40'.	51'	$44.00	2.24
	1 x 6 x 16				
3	1 x 5 x 16		20'	$45.00	.90
1	1 x 18 x 12		18'.	$49.00	.88
3	#2 Std. White Pine, S2S		72'	$44.00	3.17
	1 x 18 x 16				
8	1 x 6 x 16		64'	$39.00	2.49
9	1 x 5 x 16		60'	$40.00	2.40
	4" #1 & 2 Flooring		250'	$32.00	8.00
2	2 x 6 x 18 Mer. Cedar		36'.	$22.50	.81
50'L	5/4 x 4 Stool	250'L	21'	3/4 ¢	1.87
1	2 x 16 x 16 Sel. Mer. Yel Pine		43'	$22.00	.94
	Delivery				.35
			635'		$ 24.05

Delivered to his house on Palm Ave

Ticket 4944.

This purchase order from 1904 shows what materials were available from the Brookings Lumber and Box Company. As noted, there was "redwood lumber" available at the yard in Highland, but this did not come from the San Bernardino Mountains. Instead, it came from Oregon, as did much of the company's inventory, because lumber from the Pacific Northwest was of better quality and because it was necessary to buy lumber from mills in Oregon and Washington to compete with other lumberyards.

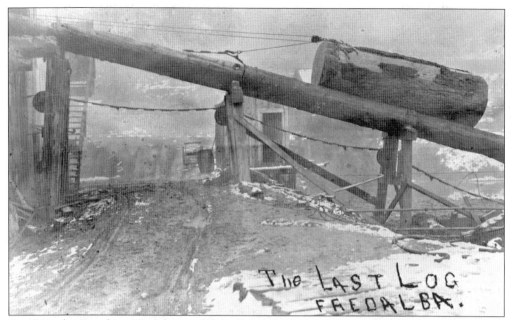

By 1914, the Brookings Lumber and Box Company ceased to exist in the San Bernardino Mountains. The mill was dismantled, rails were pulled up for scrap, and the toll road sold to the county for $5,000. The road was the main contribution to the future communities of Running Springs—Arrowbear and Green Valley Lakes. Big Bear Valley benefited because the road brought people to these communities from all over the southland.

The workers who remained after the mill was dismantled went to work for the county improving the road into the mountains. Nothing remains of the mill today except a very large wooden foundation and a cement base for a water tank or smokestack. Here Jim Sims, third from left, and students from the local elementary school study the mill remains with Howard Norwood, far right, who came to the mill as a teen and witnessed Brookings at work.

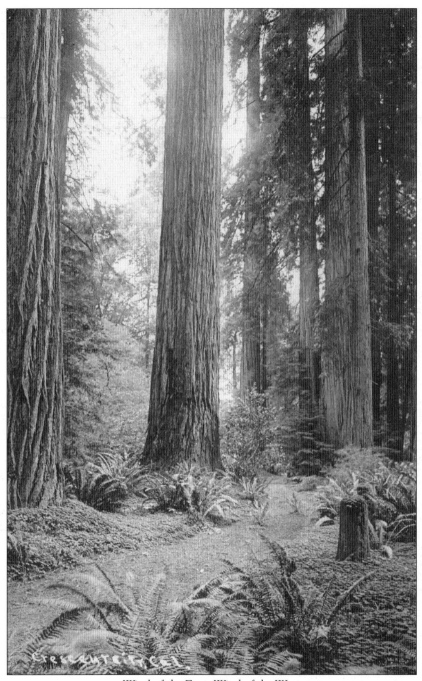

Wind of the East, Wind of the West,
wandering to and fro,
Chant your songs in our topmost boughs,
that the sons of men may know
The peerless pine was the first to come,
and the pine will be last to go!
–Robert Service, *The Pines*

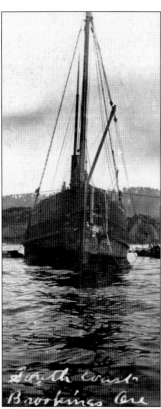

Robert Service's idealistic view of the pines is shared by modern-day ecologists, and the pines of the San Bernardinos, at least, were spared when the Brookingses moved to Oregon, bringing equipment and personnel to a new area, where they would build a new city, lay new tracks, build new bridges, and search out new timber holdings. Here the steamship *South Coast* is seen unloading at the port of Brookings, Oregon.

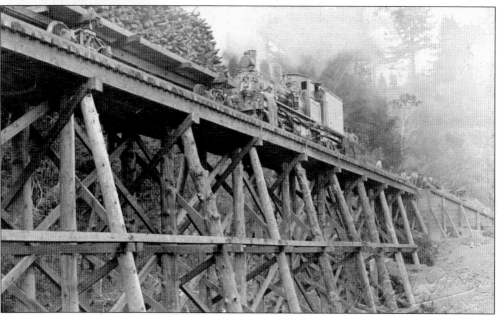

The Brookingses invested heavily in the new mill on the Chetco River, purchasing new equipment and steam engines and hiring new crews. Many of the workers from San Bernardino came along, as did E. G. Boardman (accountant) and Robert MacColl's father (commissary) and his entire family. The Boardmans and the MacColls lived in well-furnished boxcars during their stays there.

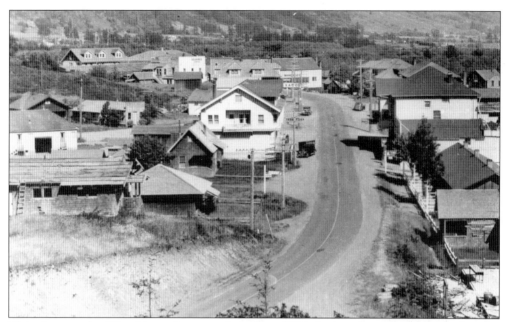

This photograph of Brookings, Oregon, taken about 1930, shows a thriving town, which today has a population of more than 14,000. The outbreak of World War I caused the lumber market to hit bottom and the Brookingses sold the mill to new owners, who called their new company the California and Oregon Lumber Company. Son Walter continued with the new company as the vice president.

Ironically this contemporary photograph was taken at a local lumberyard in the San Bernardino Mountains, where lumber arrives from Brookings, Oregon. While a chapter has ended in the history of sawmills in these mountains, the influence of the Brookings Box and Lumber Company continues more than 110 years later.

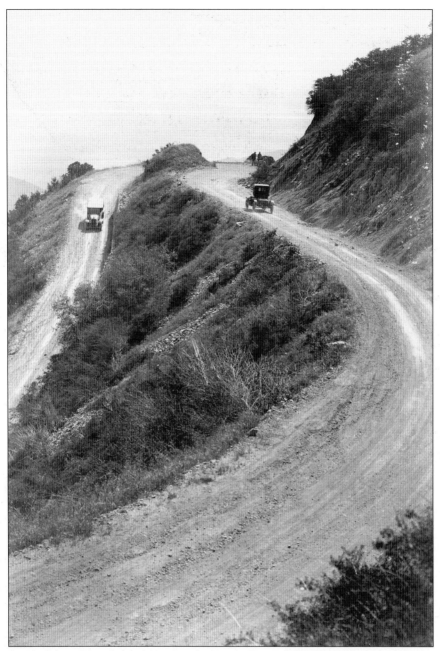

With the abandonment of the wagon road, the purchase of the roads by the county, and the improvements made for motor travel, people from all over the southland came to see for the first time the beauty of the San Bernardino Mountains. The new dam in Big Bear Valley had been completed (a rock dam had been built in the 1880s, but a newer dam raised the level of the lake), and tourists, adventurers, sportsmen, and entrepreneurs discovered a new world—and all had to pass through Hunsaker Flats, the future Running Springs. Here automobiles appear to be descending the switchback grade, but old-timers will tell you that the Model T Ford had to back up these grades since there was no fuel pump and the gas tank was located behind the seat. To keep a flow of gasoline to the engine, it was necessary to drive in reverse.

Two

RUNNING SPRINGS PARK

As tourists drive up Highway 330 or along Highway 18, few realize that they are paralleling the 1890s wagon road built by the Danaher and Brookings families more than a century ago. Perhaps a passenger who does not have to concentrate on the road might glance to the uphill side of the road and—with a little historical background and imagination—can picture teams of lumber-loaded wagons headed for the box factory in East Highlands. Clouds of dust visible in the valley below would ascend behind the wagons, and some of the drivers would sleep as the teams found their way down the trail.

But most people who drive this road are intent on reaching their destination, whether it is Running Springs or points beyond. The all-day journey of the teamsters in the 1890s has now been reduced to just minutes by powerful cars, and their operators are intent on going from point A to point B as quickly as possible. (One Running Springs resident claimed he held the record by going from town to the bottom of the hill on a motorcycle in 14 minutes!)

Running Springs is often hardly a noticed junction of Highways 330 and 18, and travelers often do not stop and explore the many conveniences there and the gift and antique shops that have sprung up. It has always been known for some fine eating places. Those who do stop sometimes return to stay, just as they have since the 1890s.

Its pleasant and relaxed pace of life is very much agreeable to those who choose to live here. While there were only a few hundred people living in this area in 1900, now there are, by some estimates, more than 5,000 permanent residents. The elevation is 6,030 feet, which means it is always above the smog that plagues other mountain communities found at lower levels. For snow lovers there is almost a 100 percent guarantee that a year won't go by that their wishes will be fulfilled. "The Springs," as locals refer to their place on the planet, is worth a visit.

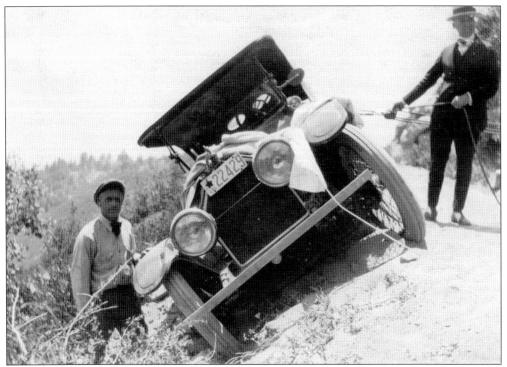

Motorists had to keep their eyes on the road and watch for automobiles coming down the hill, or they could wind up like this poor unlucky fellow. With no tow trucks available and no cell phone to call for help, one had to improvise in this situation and hope a friendly driver would come along and offer help. This driver didn't dress for this unexpected turn of events.

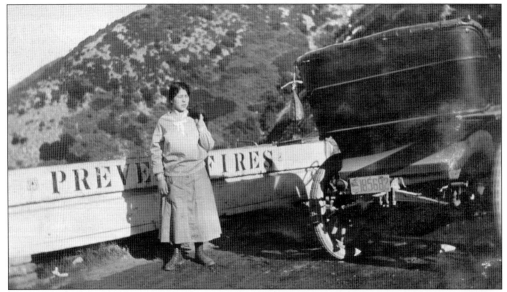

Forest fires are, and have always been, a concern to firefighters, residents, and visitors to the San Bernardinos. Without the modern-day firefighting equipment, all fire suppression in the early 1900s was accomplished by hand, and in some cases, nature caused fires to burn for weeks until there was a change in wind and weather and fire crews could get the upper hand.

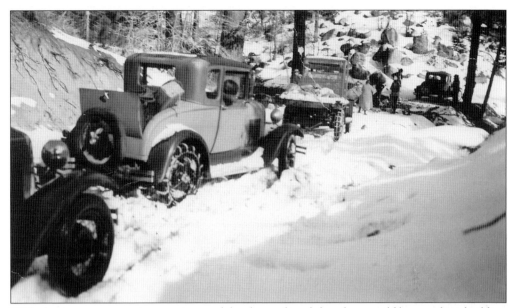

With the snows came curious tourists, and developers found that there could be a profit in building resorts and recreational areas in the mountains for these fun-seekers. Soon a new industry would grow around the needs of the families and serious sportsmen who came to hunt, fish, ski and, eventually, snowboard.

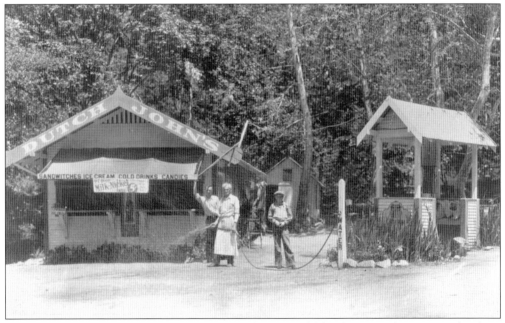

One of the most popular places to stop for a "sandwitch," cold drinks, or candies was Dutch John's, just a mile above the City Creek Bridge. This secluded and shaded spot in the road still exists today, but when Highway 330 was realigned in the 1950s, it was bypassed and is now a private and restful spot for the few who live there.

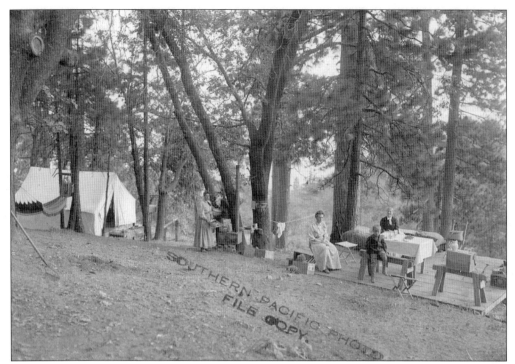

Once on the mountain, a traveler could set up camp, spend a few days, then move on to Big Bear Valley, or just enjoy the surroundings of a picturesque area like Smiley Park, where there already was a well-developed park with permanent residences. This photograph is from the files of the Southern Pacific Railroad.

Ray Poppett ran cattle in the mountains near Running Springs, and along with his brother, camped at this spot many times to tend to the stock. Over the years, this place, just north of Running Springs, has become known as Poppett Springs. The cattle industry was widespread in the mountains, and families like the Poppetts, Shays, Allisons, and Holtons were well-known ranchers.

Building booms hit the Running Springs area as early as 1896, when one could rent or lease cottages or tent houses for as little as $75 a year. In 1925, the National Investment Company from Los Angeles advertised a "country club, resort, mountain playground" near Lake Arrowhead, and Hunsaker Flats (Running Springs) saw its first influx of new property owners.

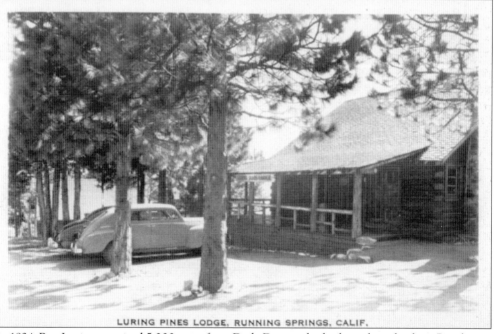

LURING PINES LODGE, RUNNING SPRINGS, CALIF.

In 1924, Ray Luring acquired 5,000 acres from Dade Davis, who had purchased it from Brookings. He subdivided the acreage and sold lots for $50 each and called it Running Springs Park. Some of the tract west of the town is still called Luring Pines, the original name of Ray Luring's tract, and the "Park" has since been dropped. A post office was opened April 25, 1927, with Albert S. Parr as postmaster.

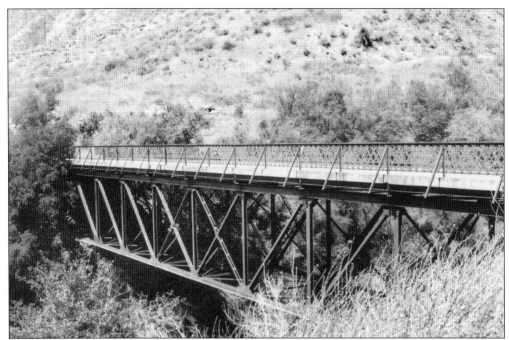

When the county took over and realigned the Brookings toll road, it also removed the wooden bridge built by the Danahers over City Creek in 1891 and replaced it with the steel-and-concrete structure, which is now closed but serves bungee jumpers and the search-and-rescue teams that use it for practicing repelling.

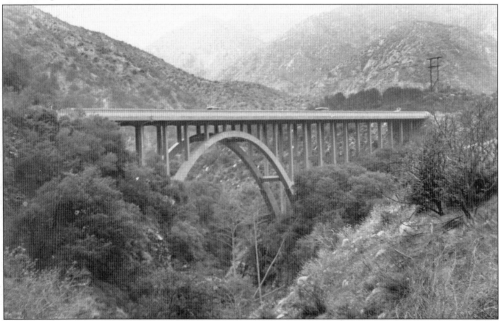

In the 1950s, the county began additional improvements on Highway 30 (330) and built this graceful and beautiful arch over City Creek. The old steel bridge was closed, and thousands of residents and visitors to Running Springs and towns beyond cannot appreciate its architectural qualities unless they stop and walk out onto the older steel bridge and view it from there.

The City Creek ranger station on the lower passing lane above the City Creek Bridge is a hub of many historical locations. Two tollhouses used to stand near this point—one was the Twin and City Creek tollhouse, and the other the Daley Canyon tollhouse to the west. Dutch John's was a mile to the east, and Barrel Springs, a watering hole for animals, was about two miles to the northeast. A Civilian Conservation Corps camp (pictured below) was built on this site.

Colby Miller, the author's grandson, views this monument near the City Creek ranger station which reads: "Commemorating Civilian Conservation Corps enrollees & officers who served here 1933–1942 f-157 City Creek, Highland, Cal CCC companies: 543-565-908-909-911-2922c-2553-2494 San Bernardino National Forest, Calif. Conservation Corps dedicated by inland empire Ch. No. 65 NACCCA San Bernardino January 1990."

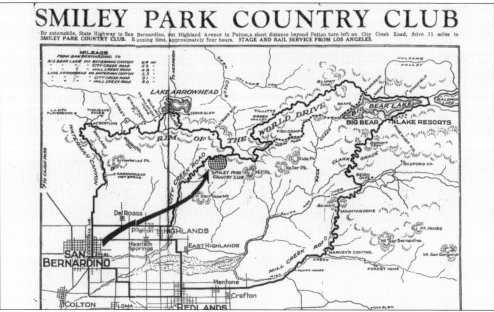

SMILEY PARK COUNTRY CLUB

By automobile, State Highway to San Bernardino, out Highland Avenue to Patton, a short distance beyond Patton turn left on City Creek Road, drive 11 miles to SMILEY PARK COUNTRY CLUB. Running time, approximately four hours. STAGE AND RAIL SERVICE FROM LOS ANGELES.

The Smiley Park Country Club was one of the first "resorts" in the San Bernardino Mountains and the first travelers saw as they ascended City Creek Road. Tourists on their way to Arrowbear, Green Valley, or Big Bear Valley would pass this way, and it soon became a popular stop, especially if visitors wanted to make a short trip to the mountains, as it was the closest club to the valley cities.

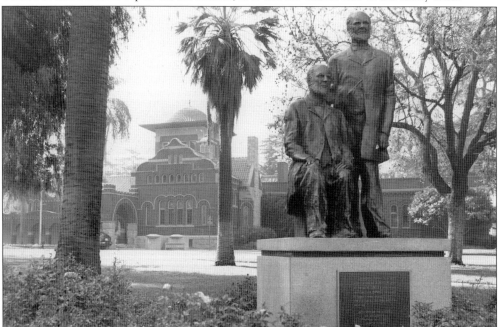

Fred and Albert Smiley, twin brothers of Quaker ancestry from the East were prominent Redlands residents, and their philanthropic contributions are monuments to their goodness. Most notable of their gifts is the Smiley Library in Redlands. Fredalba, the community next to Smiley Park, is a combination of their two first names. They are also known for the development in 1865 of the Mohonk Mountain House, 90 miles from New York City.

74

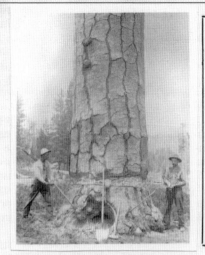

CUTTING A PINE TREE

FREDALBA PARK

A Summer Resort in the San Bernardino Mountains :: :: :: ::

FREDALBA PARK

IS a strikingly beautiful summer resort of 262 acres of land, covered with native oaks and pines, some of which are 18½ feet in circumference, and is located on the southern slope of the San Bernardino mountains, 5600 feet above the sea. It is situated at the head of City Creek toll-road, and is 11 miles from Highland, on the Santa Fe railroad, and is 16 miles from San Bernardino, and the same distance from Redlands, and is on the most direct road from these places to Bear Valley. There are six miles of comparatively level drives through the beautiful oaks and pines with views of Redlands, Riverside and San Bernardino, while on clear days Catalina and the ocean can be seen. There are seven four-room cottages, and four of three rooms, and one of two rooms—each one located in a fine group of large trees, and each one commanding magnificent views of mountains and valleys. All are built of matched and planed sugar pine, and are finished inside in the natural wood. They are furnished for light housekeeping, and can be rented by the day, week or month, at reasonable rates. There is a central kitchen and dining hall where parties can obtain meals by day or week as they may wish. Excursions can be taken to Squirrel Inn and the lumber mills—to Holcomb Valley and its gold mines, or to Bear Valley and other interesting places, all of which are within easy driving distance from the Park. The Brookings Lumber Mill is at Fredalba and has several miles of railroad bringing lumber from the woods to the mills.

Telephone call is Brookings Mill, Fredalba.
Any further information will be gladly given by addressing

FRED A. SMILEY,
Fredalba, San Bernardino County, Cal.

This early flier tells it all. Fredalba was the ideal place to spend a day, week, or month, or to buy property that could be had at a reasonable price. As previously mentioned, much of the property in this park has remained in the ownership of the original families since it first was purchased from Fred A. Smiley in the late 1890s. The Squirrel Inn mentioned in this flier was far to the west, between today's Lake Gregory turnoff and Twin Peaks, and was popular for its grand parties and social atmosphere. The inn still stands but remains privately owned, as it was when it was finished in 1893 as a private social club. The Brookings sawmill was still in operation at this time, as was passenger service on the Santa Fe Railroad, which went from Los Angeles to Molino, where the box factory was located.

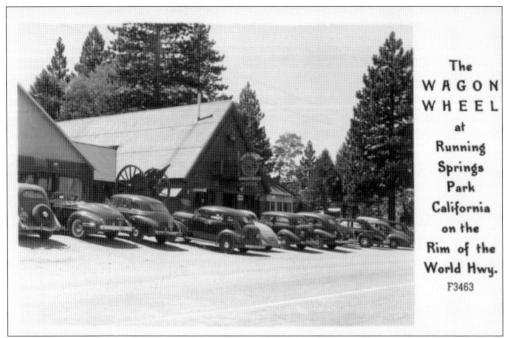

The
W A G O N
W H E E L
at
Running
Springs
Park
California
on the
Rim of the
World Hwy.
F3463

Running Springs Park, as it was called in 1925, soon became a popular stopping-off place for those who were driving on to Big Bear Lake, and it remains so today. This photograph from the late 1930s shows the downtown area looking to the west at the intersection of today's Highways 330 and 18.

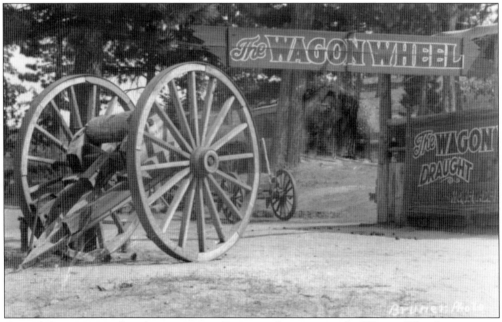

One of the most popular places to eat in Running Springs was the Wagon Wheel restaurant, owned by Bill Kissee and the Baker family. It was torn down in the 1970s, but its owner is still a prominent local resident. The wheel has since disappeared. It was located just at the west entrance to Running Springs and across from the Rusty Hammer hardware store.

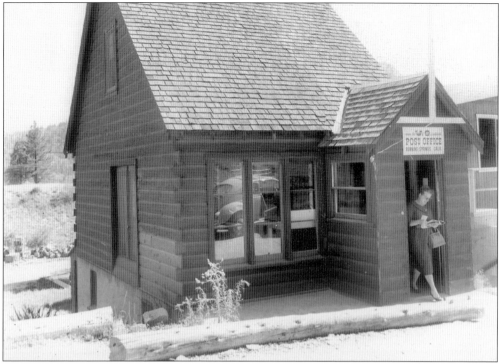

This early photograph of the Running Springs Post Office shows a reflection in the window of an early Volkswagen bug, indicating that it was taken around 1960. Local resident Dora Miller is seen leaving with her mail. The postmaster at this time was Jettie R. Bean. Today this building still stands and is a Coldwell Banker office. It is next to the Running Springs library.

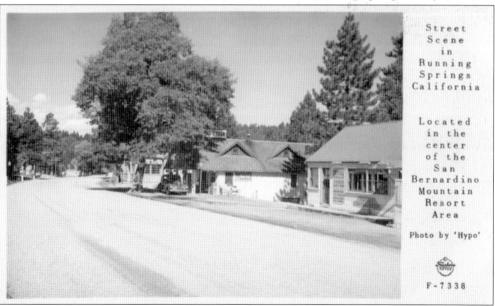

Street Scene in Running Springs California

Located in the center of the San Bernardino Mountain Resort Area

Photo by 'Hypo'

F-7338

Looking to the northwest of the main street of Running Springs, this 1930s photograph shows a service station on the corner of the junction of Palo Alto and Highway 18, near today's Rusty Hammer hardware store. The Wagon Wheel restaurant was just across the street to the south.

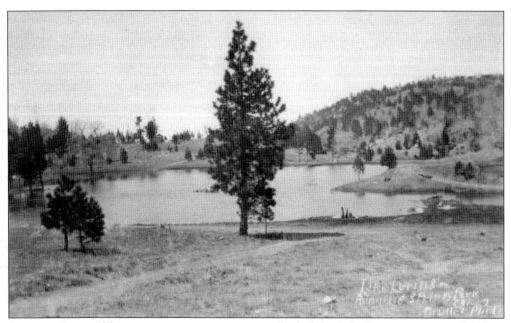

Running Springs, like most mountain communities, had a lake. Lake Luring was a popular place for swimming and fishing. There are no natural lakes in the San Bernardinos, except for Dollar Lake, which is on the south side of San Gorgonio and is actually a "pocket glacier." Baldwin Lake is sometimes a lake, depending on the amount of moisture that falls in a season.

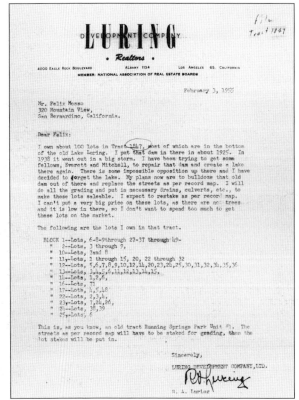

Ray Luring referred to his lake as "the old lake." The heavy winter of 1938, which damaged the dam beyond repair, was the *coup de grâce* for the lake. He gave up trying to rebuild the dam and decided to subdivide the area. Luring confided to Dade Davis before he died that while he lost tens of thousands of dollars in his lifetime, he would die a multimillionaire.

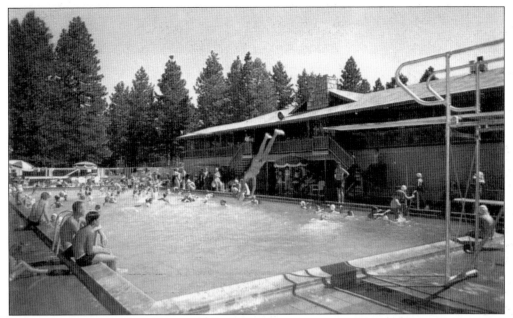

The Luring Pines development was an ideal place for permanent residents to locate, with a small but convenient shopping area nearby, churches, a bank, a post office, and this swim club and clubhouse that served the community for many years until the facility was sold and the swimming pool turned into a parking lot.

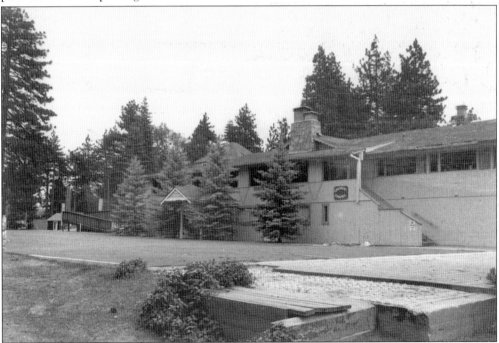

Today the Luring Pines clubhouse and swimming pool serves as a meeting place for the local Calvary Chapel, which also owns a campground on the road to Green Valley Lake. While the facility stands empty most of the week, it is a busy place when members meet to celebrate their fellowship.

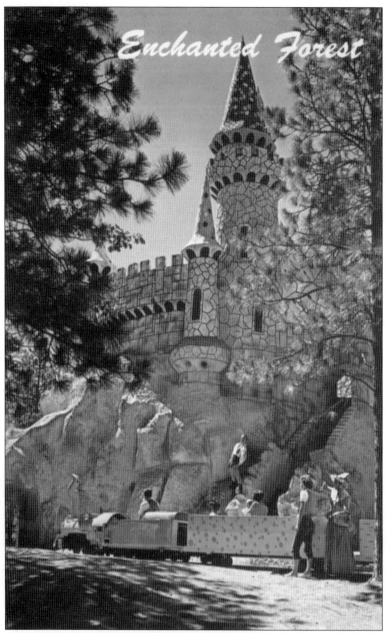

Enchanted Forest

In 1959, a group of Nevada businessmen purchased 365 acres that was at one time part of the Brookingses' holdings and developed a theme park called the Enchanted Forest to the west, where today there is a long stretch of straight road and a passing lane. It was designed much in the same way Disneyland and Santa's Village in Skyforest were. Santa's Village opened on Memorial Day weekend in 1955. Disneyland opened on July 12, 1955, and the Enchanted Forest opened in 1960 with rides, a dragon roller coaster, a castle, and a haunted witch's hollow. The goal of the park's founders was to provide "the high standards necessary as a moral force in shaping the lives of our young people with a wholesome family atmosphere," as stated in the brochure. However, hard times would fall on this theme park, as they eventually did on Santa's Village, and the property and buildings would be sold at a delinquent tax sale in 1962.

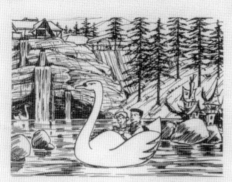

SWAN LAKE is set in a storybook locale and will take you through miniature storybook cities in a mechanized swan. This is a ride you will long remember.

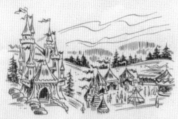

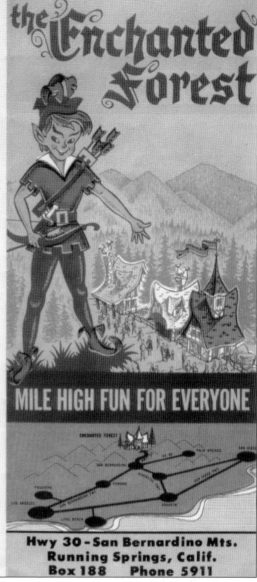

The Enchanted Forest is located on a 365 acre site, presently comprises some 16 acres within the park plus some 20 acres of parking area. A continuous expansion program is planned over the next few years to create one of the finest recreation areas in the country.

The Enchanted Forest is a theme park depicting the old Black Forest of 16th century Europe and its fairy tale setting. Our fantasy theme, made famous by the Grimm brothers, is a product of the old Norse mythology, universal religion of all Europe until the first century and the advent of Christianity.

Designed as a family park, The Enchanted Forest will cater to all age groups. As a family park, it is the aim and goal of management that everything possible be done to ensure the high standards necessary as a moral force in shaping the lives of our young people with a wholesome family atmosphere.

As travelers drive up Highway 330 toward Running Springs, they can look through the trees and still see the castle that once served as the main landmark of the Enchanted Forest. Today it houses the water tank for the residents of this track of land owned by the Harich family. Some of the buildings that were part of the theme park are still in use as living quarters for the family and workers on what has become a ranch. The developers of the Enchanted Forest missed their chance when they did not realize the potential of this tract of land, but the present owner has discovered a virtual gold mine underneath in the form of water, which is sold to a major water-bottling company. Not only is there water under the land, there are numerous springs that flow year-round. Former fire chief Bruce Horning of Running Springs once remarked that someday water would be as valuable as gold, and his prediction may soon be true.

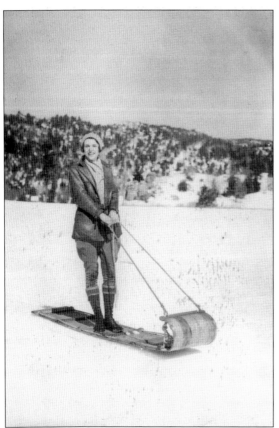

With an elevation of 6,030 feet, Running Springs is known for its occasional heavy snowfall. In this 1932 photograph, Emily Hallar tests the ice on the frozen lake surface of Lake Luring during a sunny day. Another heavy snowfall came in 1938 and melted quickly, leaving many valley cities flooded.

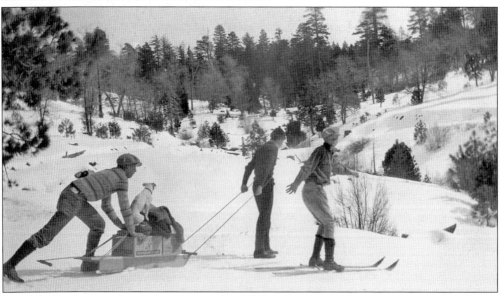

Even the dog gets to play in the snow in this 1938 snow scene in Running Springs. Paralyzing snows hit Running Springs in 1947 and 1969, closing all the roads to the mountains for almost a week. One fireman, desperate to get to his fire station, road a bicycle down Highway 330 and caught a bus to his job in Los Angeles.

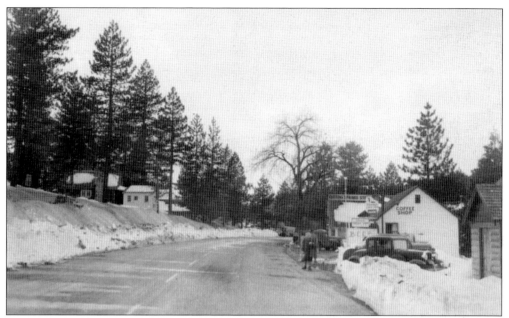

Just after World War II, the country made additional improvements to Highway 330, and the community of Running Springs began to flourish. The year 1946 marked a turning point in the local population, and GIs home from the war found Running Springs to be an ideal place to try to forget the military life and its challenges and to explore opportunities in the mountains.

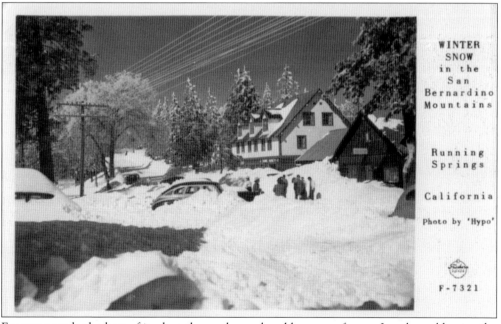

WINTER
SNOW
in the
San
Bernardino
Mountains

Running
Springs

California

Photo by 'Hypo'

F-7321

Everyone made the best of it when the road was closed because of snow. Locals could enjoy the Wagon Wheel restaurant; Lloyd Suter's soon-to-become "world famous" Lloyd's Restaurant, made famous by the pies he made there; as well as skiing or sledding, either on the local mountain slopes or at the Snow Valley resort.

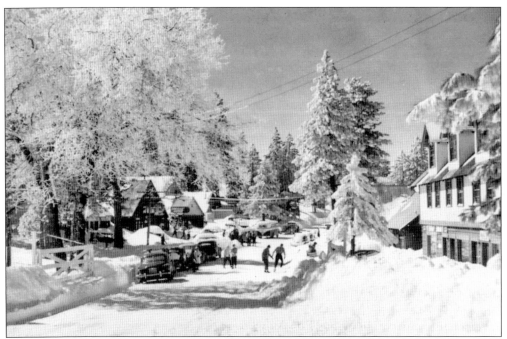

When the roads were finally plowed, as seen in this late 1940s photograph, people began to arrive and businesses thrive. Local children enjoyed the snow, especially during school days because—unlike down the hill—when there was too much snow, school was (and still is) called off until the buses could gather them up.

Not many remember when gasoline was as low as 29¢ for a gallon of regular gas. At the same station today, at the corner of Hunsaker and Hilltop Roads, gasoline is approaching $4 a gallon for regular. This mid-1940s photograph was taken looking west along Highway 330. By this time, Lloyd's Restaurant was a well-established landmark in the Running Springs area.

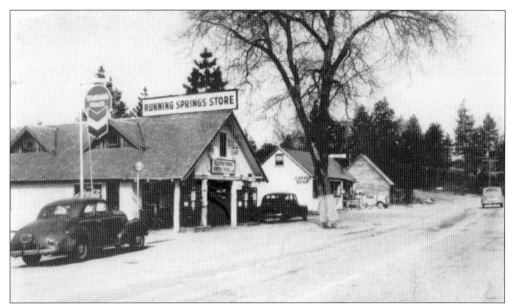

This photograph from the late 1940s shows the Running Springs Store and the Standard service station on the corner of Hilltop and Palo Alto Streets. Not only was this an important stopping place for travelers going either direction, it served as the post office during the 1930s and 1940s with Anna M. Ingvaldsen (later Robertson) as postmaster.

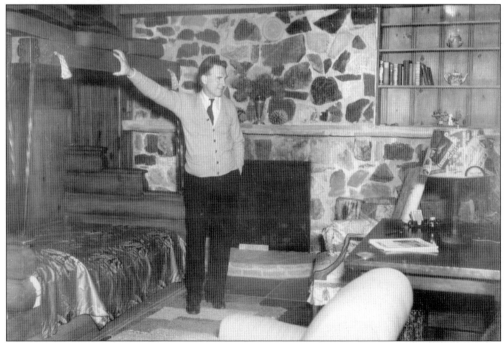

Running Springs is not without its Hollywood celebrities. In this photograph, Walter Huston stands before the fireplace in his bedroom at his cabin in Running Springs "overlooking Lake Arrowhead [sic]," as the caption to the photograph reads. Here he and his wife, Nan Sunderland, entertained many of Hollywood's best-known celebrities, including James Stewart and Beulah Bondi, who were costars in the film *Of Human Hearts*, filmed in Lake Arrowhead.

Today the main street in Running Springs provides almost all the conveniences of a small community down the hill. There are three markets, an automobile-parts store, a library, a pizza parlor, gift stores, a hardware store, financial advisors, a graphic artist, restaurants, lodging, contractors, a bank, real estate offices, a tanning salon, and a video store.

In times past, Running Springs, like most mountain communities, virtually closed down during the week after Labor Day, but today as many as 100,000 travelers on their way to Big Bear Valley or Snow Valley pass through the town, swelling the local population on weekends. Many have come back to live permanently and commute to jobs as far away as San Diego or Orange County, leaving early in the morning and returning late at night.

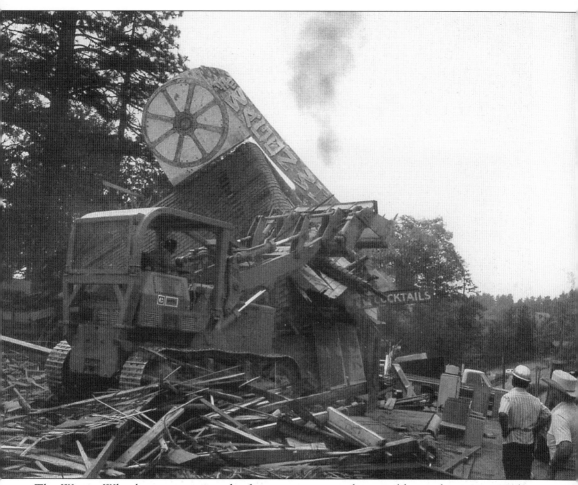

The Wagon Wheel restaurant was the first structure travelers would see when entering the community of Running Springs from the 1940s to 1974. It was a meeting place for community organizations and served at times as a schoolhouse, post office, polling station, and living quarters for family and foreign visitors coming to ski at Snow Valley. Many of Hollywood's celebrities came through its doors. It was here that many community socials were held. (Jill and George Disseaux met here and later married). But as happens to some historical landmarks, it fell into decay—a fire broke out inside, animals found it an ideal place to breed and inhabit, and it was finally declared a public hazard and torn down in 1974. Now the location is a vacant lot used for weekend flea markets and a place to display cars "For Sale." Those who remember it as a place to have an enjoyable night out with fine dining, to go to school, or to pick up their mail will always remember it with a great deal of nostalgia.

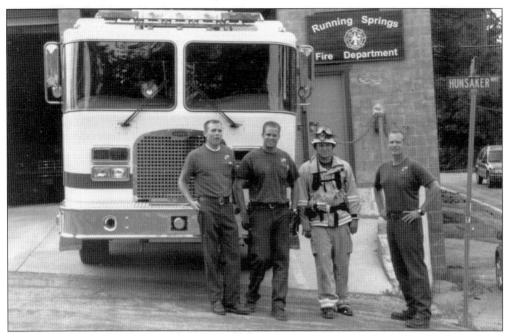

The Running Springs Fire Department in the 1940s consisted of all volunteers who had to chip in to buy gasoline for the one engine. Now there are several stations with state-of-the-art equipment and full-time firemen as well as volunteers. Pictured here are, from left to right, Hans Strebel, Richard Bethel, Brian Talbott, and Mike Olsen.

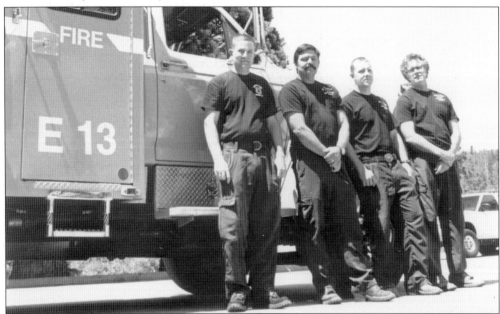

The Running Springs Fire Department is supported by the USFS because much of the mountain communities are surrounded by national forests. This crew serves the Deer Lick ranger station, and they and the Running Springs Fire Department work in tandem, not only on fire and rescue but also on frequent automobile accidents. Pictured are, from left to right, Chris Crowder (engineer), Troy Nelsen (captain), Dale Brooks (assistant captain), and Johnny Ralston (firefighter).

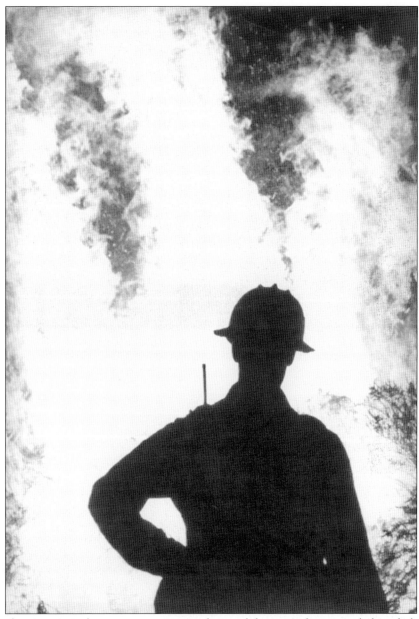

On October 21, 2003, the mountain witnessed one of the worst fires recorded, and almost the entire mountain was evacuated while 91,281 acres and 993 homes burned. The "Old Fire" shifted as the Santannas (Native American word for "devil winds") blew the fire down the hill, around Cajon Pass, and then back up the mountain. Rumors spread as many tried to gather information on the condition of their homes. Some were surprised to find their houses standing after they had been told they had burned, but others unhappily experienced the opposite. The local news channels could not seem to get it right. "Rim of the Forest High School in Blue Bird has been destroyed," one newscast reported, confusing the names with Rim of the World High School and Blue Jay, and the author, who remained on the hill during the fire, was reported dead! It looked as if there would be nothing left before the fire was brought under control at a cost of $42,045,093. (Courtesy of Michael Oliver.)

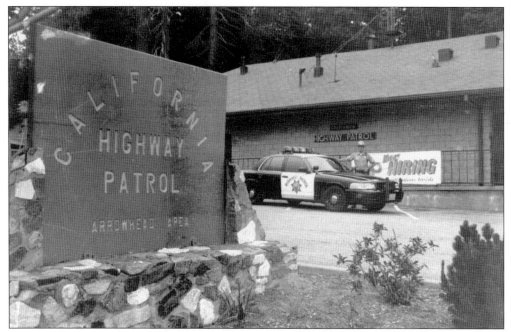

Running Springs was chosen as the Arrowhead Area station of the California Highway Patrol due to its central location to most mountain communities. The officers have a difficult task, patrolling the 100,000 visitors who may come on any given weekend. Here Wallace Wood, a fourth-generation CHP officer, is pictured in front of the office with his cruiser.

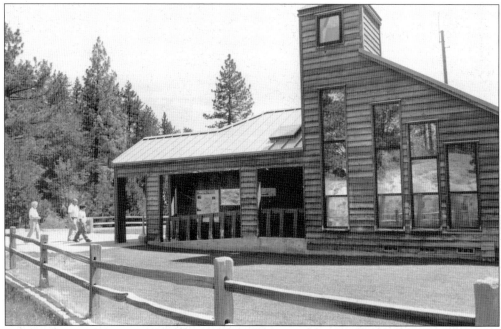

The USFS operates visitor centers in various parts of the San Bernardino Mountains, and this one in Running Springs is a branch of the Discovery Center on the north shore of Big Bear Lake. It has a small gift shop and is open on weekends only. Here visitors can get directions to all points of interest in the district.

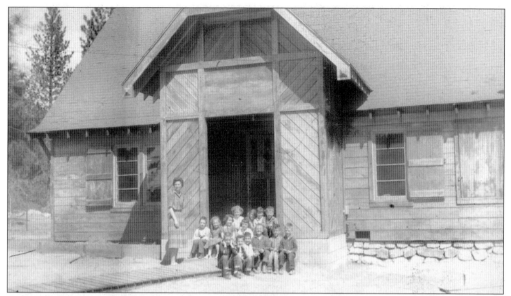

Before World War II, the Running Springs schoolchildren met in the Wagon Wheel restaurant, where Connie Dodge served as teacher. Students avoided the bar by entering a side door, except on snowy days, when they passed by the bar to get to the classroom. In this 1960 photograph, the kindergarten class meets at the Women's Club, where Eileen Hoenig served as teacher. Chip Hoffman, the son of the principal, can be seen at far right.

The Running Springs Elementary 1960–1961 staff pictured here are, from left to right, as follows: (first row) Chuck Hoffman, principal; Ann Martin, fourth and fifth grades; Jim Sims, fifth and sixth grades; and Pauline Tierney, noon duty; (second row) Dorothy Mueller, first and second grades; Bob Atchinson, bus driver; Dora Miller, cook; George Hayward, custodian; Eileen Hoenig, kindergarten; Sheryle Youngman, third grade; Herry Weiss, music; and Ellen Bermeister, cook.

Sawmills have not totally disappeared from the Running Springs area. Jeff Hild, shown here, and his father operate a private mill and supply lumber in sizes to neighbors according to their specifications. While it may not produce 60,000 board feet a day, as Brookings did, it can supply enough for small projects, as long as the timber is available.

Steam-powered donkey engines have now been replaced by heavy-duty diesel-powered equipment and logging trucks that move burned trees from the forest at a speed that would astound the Danahers and the Brookingses. Here David Noble's Southern Bay Timber, out of Ashland, Oregon, loads trees either burned or ruined by bark beetles for transport to sawmills down the hill.

Four miles up the Keller Peak Road from Running Springs is the popular Children's Forest. This is a half-mile nature trail that offers a pleasant walk for families who want to enjoy the fresh mountain air without exhausting anyone. The Children's Forest provides a view of Snow Valley from the south side and the lake that feeds the snowmaking equipment for the ski slopes.

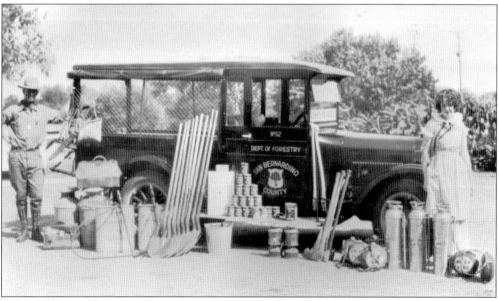

In this 1925 photograph, county fire warden Roy M. Tuttle is seen with the firefighting equipment he and his crews used to fight the many fires that plagued the mountains. Without the use of aircraft, fires were fought by hand. Tuttle was one of the first advocates of fire safety in the county and spoke to civic groups throughout the area to encourage preparedness.

There are three fire lookouts on the Mountaintop District of the San Bernardino National Forest. When visiting Running Springs, one should not miss a visit to the 7,882-foot Keller Peak, where on a clear day Catalina Island can be seen. It is the oldest existing lookout in the forest. Built in 1926, it is a 14-by-14-foot wooden cab that survived the Bear Fire of 1970 and the Old Fire of 2003.

Volunteers Wayne and Maggie Gillespie from Running Springs scan the mountains for smoke. Their bird's nest overlooks not only the local mountains, but also the San Bernardino Valley, the San Gabriel Mountains, Sugarloaf Mountain, and the high-desert communities. It is open from 9:00 a.m. to 5:00 p.m. daily during the fire season. The peak was named for Alley Carlin Keller, who was born 1868 and was an early USFS ranger.

Wilma E. "Billie" Murphy, along with her dog Lady, was a volunteer and host at the Keller Peak lookout from 1939 to 1965. Thousands of visitors to the tower will remember her and her ability to locate fires in the making. Her 26 years on the job is unprecedented in the history of the forest.

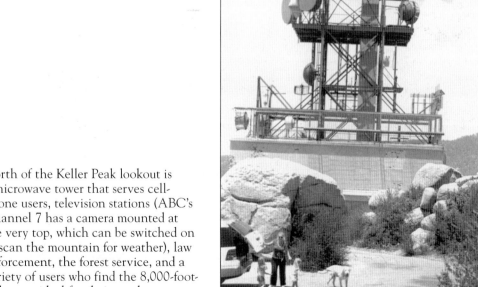

North of the Keller Peak lookout is a microwave tower that serves cellphone users, television stations (ABC's Channel 7 has a camera mounted at the very top, which can be switched on to scan the mountain for weather), law enforcement, the forest service, and a variety of users who find the 8,000-foottall tower ideal for their needs.

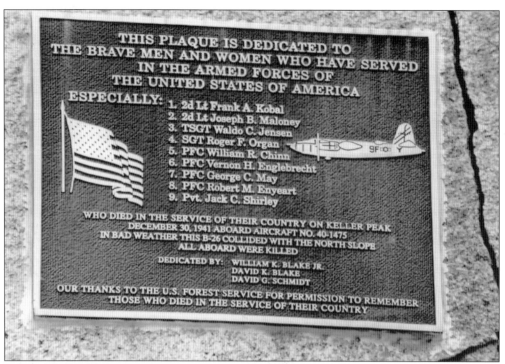

THIS PLAQUE IS DEDICATED TO
THE BRAVE MEN AND WOMEN WHO HAVE SERVED
IN THE ARMED FORCES OF
THE UNITED STATES OF AMERICA

ESPECIALLY:
1. 2d Lt Frank A. Kobal
2. 2d Lt Joseph B. Maloney
3. TSGT Waldo C. Jensen
4. SGT Roger F. Organ
5. PFC William R. Chinn
6. PFC Vernon H. Englebrecht
7. PFC George C. May
8. PFC Robert M. Enyeart
9. Pvt. Jack C. Shirley

WHO DIED IN THE SERVICE OF THEIR COUNTRY ON KELLER PEAK
DECEMBER 30, 1941 ABOARD AIRCRAFT NO. 40-1475
IN BAD WEATHER THIS B-26 COLLIDED WITH THE NORTH SLOPE
ALL ABOARD WERE KILLED

DEDICATED BY: WILLIAM K. BLAKE JR.
DAVID K. BLAKE
DAVID G. SCHMIDT

OUR THANKS TO THE U.S. FOREST SERVICE FOR PERMISSION TO REMEMBER
THOSE WHO DIED IN THE SERVICE OF THEIR COUNTRY

Tragedy struck on December 30, 1941, when a B-26 bomber, lost in the fog and off-course on a flight from Muroc (Edwards) Air Force base on the high desert to March Airfield in Riverside, struck the mountain about a half mile west of Keller Peak. A complete record of this unfortunate accident at the beginning of World War II has been put together by Arrowbear resident David Schmidt and is located in the Keller Peak lookout.

Two engines remain from Aircraft No. 40-1475, and pictured here is Kenny Wood with one of the two engines. It is a difficult hike to the engines and is not recommended as a family venture, but for those who want to attempt it, here are the GPS coordinates: upper engine, N. 34E11.838 feet, W117E03.073 feet; lower engine, N34E11.852 feet; W117E3.116 feet. Long pants, long sleeved shirts, and heavy footwear are a must.

The Running Springs area is an ideal location for youth camps. There are Boy and Girl Scout camps, church, music, YMCA, and private camps for boys and girls. Several camps are used for outdoor education by school districts throughout the southland. There are more than a half dozen camps in the area, and Camp O'Ongo has seen thousands of youth and families at its facility for almost 70 years.

Camp O'Ongo, now Pali Mountain, was developed as a private, long-term boy's camp in 1940 by Albert C. "Press" Preston and Esther "Mother" Preston with help of their son Jim. A year later, it became a coed camp. Press operated O'Ongo, drawing from his previous experience as a YMCA director. Tom Preston, the younger son of Albert and Esther, grew up in camp (seen in this 1955 photograph) and took over the directorship after Press's heart attack. He ran it from 1959 to 1991.

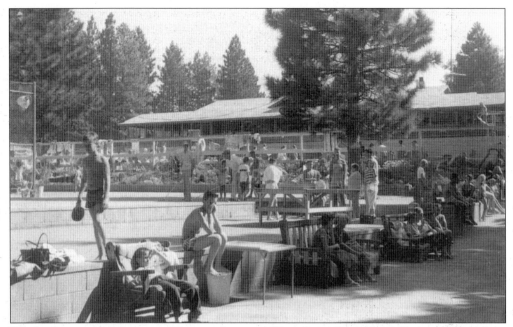

While the youth of Running Springs often complain about the lack of things to do and say they would rather live near the beach and while many recreational centers, such as this Luring Pines Club, have disappeared, the community has come together and built new sports complexes and parks for toddlers.

The former Running Springs School District is now part of the Rim of the World Unified School District, which covers the mountain from Cedar Pines Park to Green Valley Lake. Children from Green Valley Lake, Arrowbear Lake, and Running Springs attend this K-6 elementary school, from which approximately 85 sixth graders graduate each year. These students are then bused to the intermediate school in Lake Arrowhead the next year.

When the Catholic church was moved from this location, the community saw an opportunity to improve the site and build this park. Not only does it occupy the land where the church was, it is where the Danahers placed their first outdoor mill, where Ray Luring created a lake, and where the "Frog Pond" used to exist. The area north of this park today is the industrial section of the town.

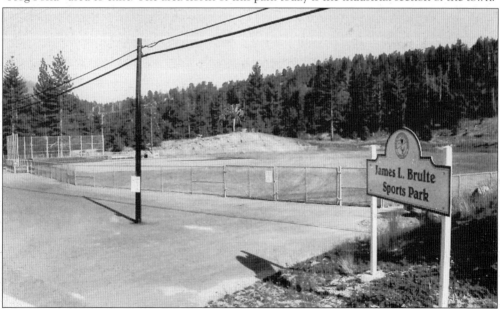

The sports field next to the elementary school was developed and named for state senator James L. Brulte, who was instrumental in the financing of the project. The Running Springs community is very sports minded and youth oriented and can field teams in all sports, including snowboarding and skiing. These two last sports have brought many honors to the members of the high school team in competition at Mammoth Lakes.

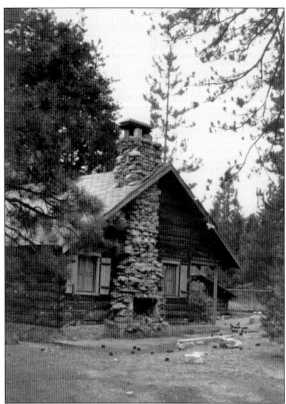

This old, 700-square-foot cabin, built in the early 1920s and located near the downtown area, is made of logs and has a rock fireplace. Many such cabins were built before World War II, but most have fallen into disrepair or have buckled under the weight of snow after a heavy snowstorm.

This new home, located in a secluded spot in Running Springs, offers the privacy and amenities many families would cherish. Many of these "cabins" are second or third homes of affluent people who may have residences in other states or countries and who might visit the mountains only a few weekends a year.

A popular yearly event in Running Springs is Mountain Top Days, which includes a parade on Saturday and a fair on Sunday at the local school. In this photograph, Smokey the Bear poses beside a Model T Ford built especially for the USFS. The Ford was equipped with special suspension so it could handle the mountain terrain.

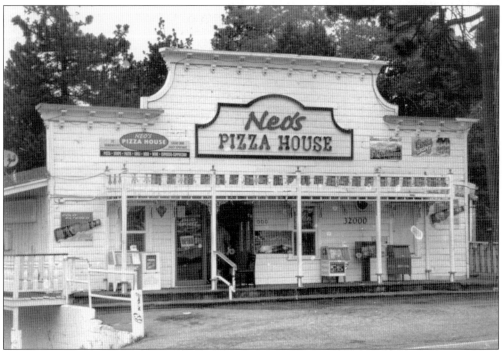

Downtown Running Springs is unique in many respects, especially because of its pizza house, which displays a type of architecture seldom seen in the local communities.

"Hunsaker Flats—The two-wheel logger placed at this location was used in the last part of the 19th Century by Brookings Lumber Company to Harvest timber from this location. Pulled by oxen the wheels which stand seven feet tall straddled the large pine logs lifting one end as they were dragged to waiting steam locomotive engines which carried them to the Brooking's mill at Fredalba near Smiley Park. Here the logs were cut into building lumber for constructing homes and businesses in San Bernardino and Los Angeles counties. The wheels were restored by the Running Springs area Chamber of Commerce and placed in their present locations as a county point of historical interest." This monument is located at the place where one leaves the central district of the town, and many visitors and residents drive by without noticing or reading the historical plaque, which gives a capsulated presentation of the beginning of the community. Pictured here are, from left to right, local residents Kathleen Ferrara, business owner Sony Northington, John and Carolann Crater, Audrey and Pete Ferrara, who is holding recently born Rory Ferrara.

Three

ARROWBEAR LAKE

"Right on this road 0.7 m. to tiny ARROWBEAR LAKE, on the shores of which is the VILLAGE OF ARROWBEAR (7,800 alt, 75 pop), with a post office and general store. Scattered along the lake front are numerous camps . . . "

—The WPA Guide to California (1939)

Hidden from the view of the thousands of travelers headed for Green Valley Lake or Big Bear Valley is a small community of permanent mountain residents who occupy a place of their own, undisturbed by the outside world. The Brookings Lumber and Box Company logged this area, and the same area was sold to Dade Davis and Charles Faulke, who purchased the 240 acres in 1922 from Brookings's representatives. The two entrepreneurs sold it almost immediately and made a profit of $5,000. It then became known by its present name. Almost all of the property owners live here year-round and work in the mountains or commute to jobs down the hill. There are many weekend cabins, a well-groomed, beautiful ballpark, the Arrowbear Music Camp, and a restaurant. There is a "lake," but it's really more of a pond. The community has seen better days, but when and if some investor realizes its potential, it may become the mountain retreat it once was. As the WPA guide recorded, there were at one time numerous camps, both private and public. These have since disappeared, with the exception, of course, of the music camp.

Because of its proximity to Running Springs, they share the same conveniences as the residents of that community. In nearby Deer Lick, a community considered a part of Arrowbear Lake, there is a lumberyard, a car wash, a gas station, restaurants, a gift shop, and a store that sells only jerky. In addition, Deer Lick has its own fire station, which is unmanned, but local on-call firemen are able to respond quickly to any emergency.

The entrance to Arrowbear Lake begins about a half mile to the east from downtown Running Springs. This small Deer Lick business district has been a popular stopping place since the 1920s and continues to be so, especially in the winter, when ski- and snowboard-rental shops open their doors to serve the needs of the visiting "snow bunnies," as they are affectionately called by the locals.

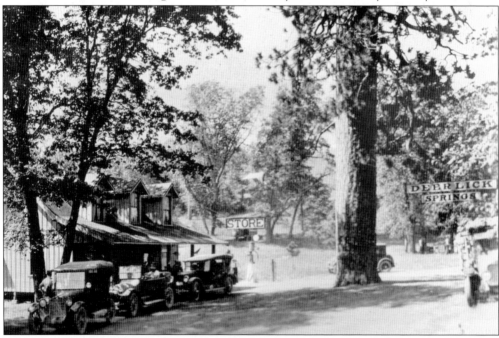

Pictured in this early photograph from the 1920s is Albert Powers' Deer Lick Springs store, which was located in about the same location where Steve Aguirre's rental yard is today. Powers operated the store most of the year and stocked all the goods necessary for those who needed a restful place to stop on their way to Big Bear Valley or who were on their way back down the hill.

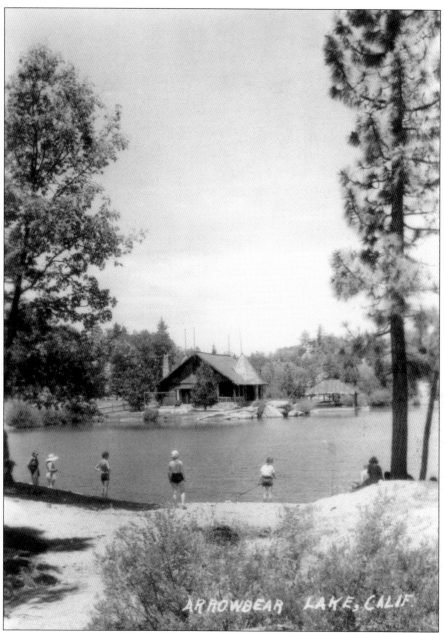

ARROWBEAR LAKE, CALIF.

In 1924, M. E. Carlock subleased the Arrowbear property from E. R. Capstaff and incorporated it as the Arrow-Bear Company. Carlock subdivided the property and hired Helmar "Swede" Nyquist to build the concrete dam, which formed the five-acre lake seen here. It was stocked with trout, and the 50 cabins he built filled quickly. Across the lake is the clubhouse, which was the focal point of social activities for the community. While the clubhouse no longer stands, the cement foundation of the cabana remains and is a popular point from which fishermen cast their lines. In addition to the clubhouse, the creation of the lake, and cabins, a garage was built to service automobiles. Most of the cabins have since fallen into ruin and have been replaced by more modern, well-kept, and well-landscaped properties, which show a community pride among most of the property owners.

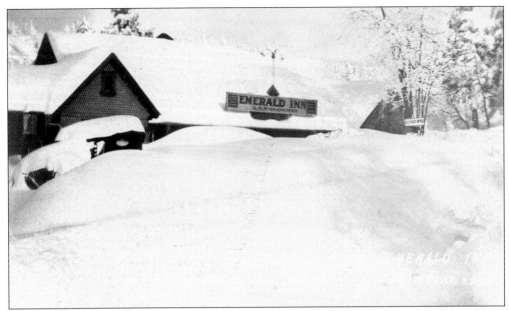

The Emerald Inn at Arrowbear Lake was hit by this heavy snow in the 1920s, and in this highland community (the AAA map states that the lake is actually 6,080 feet above sea level, not the 7,800 feet stated in the WPA guide of 1939), the 75 or so people who lived there learned what it meant to survive without the basic utilities.

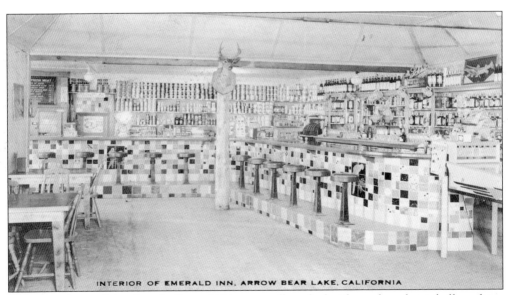

INTERIOR OF EMERALD INN, ARROW BEAR LAKE, CALIFORNIA

Come snow or good weather, the Emerald Inn was well stocked with goods and a pinball machine for those who didn't mind losing a nickel. Like most of the structures built at Arrowbear Lake, the inn no longer exists, and few have any memory of it.

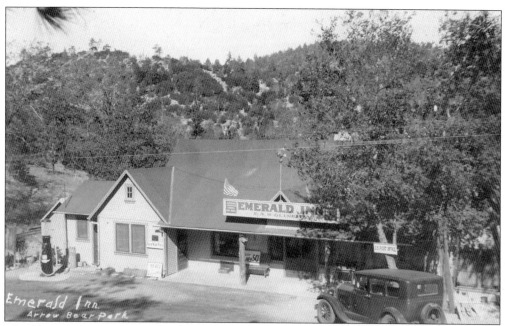

This 1920s photograph shows the Emerald Inn during good weather. The Arrowbear Post Office was inside the inn. The post office opened December 31, 1927, with John Holman as postmaster. It was discontinued several times and reestablished many times.

This rare postcard from Arrowbear Lake, dated October 10, 1929, and addressed to the *Los Angeles Times* reads, "Halloween Dance at Emerald Inn Arrowbear Lake, Saturday, October 29th. Turkey Dinner $1.00 served from 1 p.m. to 8 p.m. Prizes for the best costume." There is no record of whether they went trick-or-treating after the dance or not.

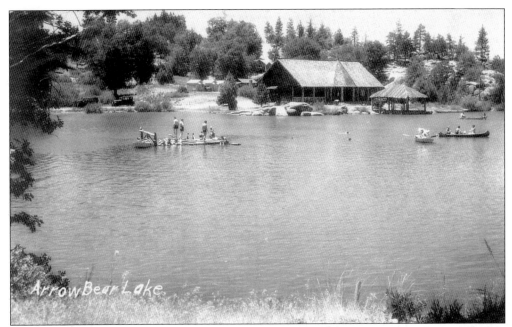

This view across the lake, looking west towards the clubhouse, shows Arrowbear Lake alive with activity. Now the activities are limited to fishing, but because of the high pollution level, fish are considered not safe for human consumption. Nevertheless, some fishermen will say that, with a little tartar sauce, it tastes OK to them.

Here is a contemporary view of the lake, taken from the same location as the photograph above, minus the clubhouse, cabana, and any activity on the lake. The concrete foundation of the cabana can be seen near the center of the photograph, and nobody is swimming in the lake (or pond, as some call it).

When the South Fork of Deep Creek runs full, the lake is at its best and is refreshed by the clear, cold water flowing from the melting snows on Keller Peak. This condition was captured in this beautiful photograph, taken almost in front of the home of its contributors, Mr. and Mrs. Richard Tucker, who have experienced the beauty of the area over the past 26 years.

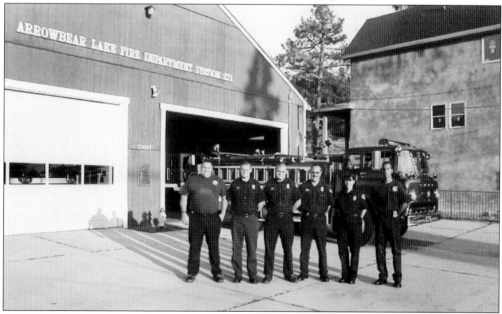

The Arrowbear Lake Fire Department is a volunteer station but can be called into action when Running Springs or the forest service needs it. In one three-month period, the department was called out 86 times, which is a typical amount for that length of time. Pictured here are, from left to right, Paul Miller (captain), and volunteers Jeremiah Chew, Matt Perkins, Aaron Byers, Debbie Clevenger, and Tim Parcells.

"In the Playland Above the Clouds"

ARROW-BEAR
PARK

On the Rim of the World Drive
Midway Between

ARROWHEAD and BIG BEAR LAKES

BEAUTIFUL WOODED

CABIN SITES
$100 and up

★

Arrange with This Office for a Special Trip
to ARROW-BEAR PARK

★

CLEDITH P. GOODWIN ASSOCIATES

528 H. W. HELLMAN BLDG., LOS ANGELES
MU-4681

HOW TO GO TO
Arrow-Bear Park
"On the Rim of the World Drive"

All those living in Southern California should go direct to San Bernardino, then take any street going north that connects with THE RIM OF THE WORLD DRIVE. Keep on this famous high-gear paved highway until you reach our TRACT OFFICE in ARROW-BEAR PARK. This scenic wonderland is approximately 35 miles from San Bernardino. Those who wish to take the City Creek Highway should go east from San Bernardino to Highlands, thence up the grade. The City Creek Highway is a good safe road but not high gear in all places. It is soon to be shortened and improved at a cost of $1,500,000.00. For this reason we advise the Rim of the World Drive out of San Bernardino, which goes direct to ARROW-BEAR PARK.

NEW CITY CREEK HIGH GEAR ROAD TO COST $1,500,000.00

Those who do not have their own cars and wish to spend a day at ARROW-BEAR PARK may make arrangements by mail or in person in our office to go to the Park in one of our cars. It is one of the most scenic trips in the world and a day spent in the mountains will give you much pleasure and zest. The altitude is 6,300 feet and ARROW-BEAR PARK is in a setting of stately pines, sturdy oaks, unique rock formations and racing trout streams. We shall be delighted to have you go up with us at any time.

This 1929 brochure outlines the advantages of owning property in the newly developed Arrow-Bear Park and makes offers would have been hard to refuse. M. P. Carlock, president of the Arrow-Bear Lake Corporation, a few years earlier offered free life memberships in the "Arrow-Bear Lake Outing Club" to anyone who would purchase land in the new development. The membership included use of the soon-to-be-built swimming pool, "the club house and special low prices on meals, boats, swimming and saddle horses." For $369.50, one could purchase land and 10 shares of stock in the corporation. Some 3,000 cabin sites were available. It was soon to be, stated his flier of 1926, "the most popular resort in the San Bernardino Mountains." The pleasant climate and 6,300-foot (actually the lake is about 6,150 feet above sea level) altitude was ideal for not only healthful recreation but to secure "Pleasure, Health, Happiness." (Courtesy of Nancy Seccombe).

A family finds that the best spot to fish on Arrowbear Lake is from the foundation of the former clubhouse's cabana floor. Little do they know that at an earlier time, there were young campers swimming and boating in the once charming lake and that a very active clubhouse once stood there, where the echoes of happy people dancing, singing, and dining at the Emerald Inn have since faded into the past.

"June 20, 1934 . . . John: I am having a swell time, wish you were here. We go fishing, swimming, hiking, etc. I am now going swimming at the lake. So' long 'Mike.' " This postcard sums up the experience of thousands of youth who knew the area during its prime. Now the task remains for some individuals to restore the lake to its former beauty.

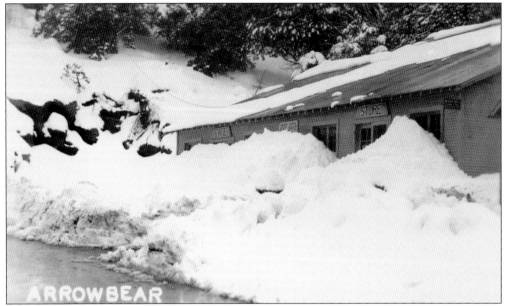

One of the favorite stops along the highway to Big Bear was this restaurant, where travelers could not only find a good, hot meal, but where they and the residents of Arrowbear could purchase goods. As noted on the front of the building in this 1928 photograph, this was also one of the locations of the post office for Arrowbear. The postmaster was Glen Smith.

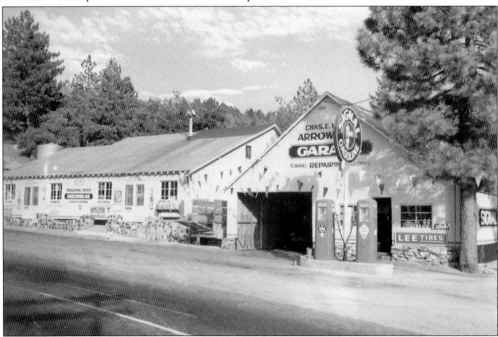

This building still stands today at the entrance to Arrowbear Lake and has become known as Blondies. In the 1930s, there was a garage located here for the frequent breakdowns (usually overheating automobiles) that occurred when traveling up the mountain roads. "Here above the clouds you get all the joys and pleasure of life with little of the sorrows and troubles of the cities and the valleys below," read a 1929 brochure.

Four

GREEN VALLEY LAKE

Green Valley was the gateway to Big Bear Valley. There was no Arctic Circle, the name given to present-day Highways 18 and 330, which run along the south side of the mountain. A traveler, whether on horseback, in a wagon, or using an automobile, had to go around the north slope of the mountain through what was known as the Snow-Slide Road. These roads were, as previously mentioned, toll roads built by private investors. Ben Pitts built the toll road house at the east end of Green Valley (there was no lake then) and also provided meals and lodging for those who wanted something to eat or a place to stay. His toll charges were as follows: one animal and vehicle, 50¢; two animals and vehicle, 75¢; three animals and vehicle, 90¢; four animals and vehicle, $1; six animals and vehicle, $1.25; each additional span, 25¢; saddle animals, 25¢; pack animals, 25¢; loose horses, mules, and cattle, 10¢; and sheep, 25¢. The George "Dad" Tillitt family arrived in 1903 and took over the operation of the tollhouse; Tillitt brought his entire family with him, and they have become legendary in the valley.

In 1925, a dam at the west end of the valley was conceived, and after funds were obtained, it was built. By May of the following year, the lake was filled. The early visionaries saw the possibilities of the valley, and their ideas have since become a reality. It is secluded from all the other mountain communities—a peaceful and quite place where artists, retired people, and those who just don't want to live with the congestion, crime, and pressures of city life can live. But it is not a place for everyone. The solitude, the long drive to jobs down the hill, and the possibility of being snowed in can wear on people, some of whom develop a mountain psychological illness called "cabin fever." However, for the strong willed and those who are content with themselves, there are few places on earth that can rival its beauty, fresh air, clean water, and friendly and close-knit community.

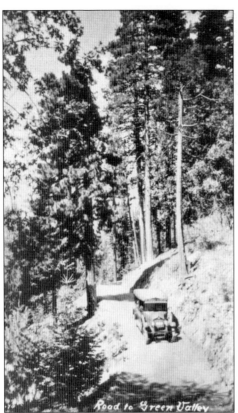

The road to Green Valley, shown in this 1915 photograph, was actually the railroad bed left by the Brookings Lumber and Box Company. According to the Tillitts, it went all the way to the tollhouse. But in later years, some believe it actually ran only to Camp No. 7 because "Green Valley" may have been a geographical term to cover everything from the tollhouse to the camp.

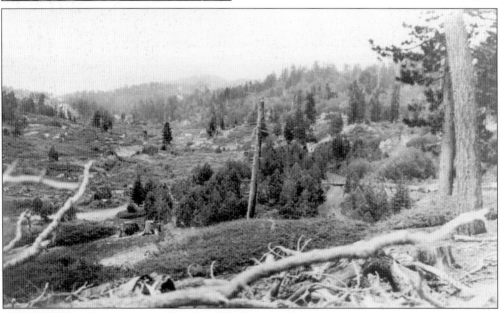

Green Valley is shown in this photograph before there was a dam. The toll road to the south ran around the valley, to the tollhouse, over Snow Slide Road, and came out at Fawnskin at the northwest side of Big Bear Valley. It was Harry McMullen, nicknamed "Green Valley Mac," who envisioned a mountain community built along the shores of a lake in this valley.

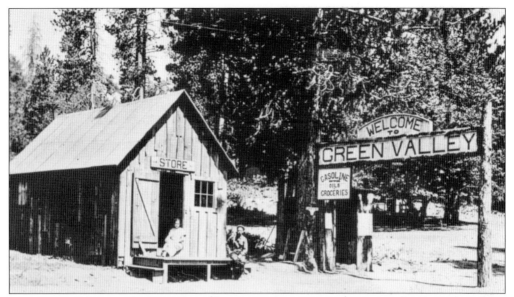

This c. 1900 photograph shows the tollhouse for those entering Green Valley from the east as well as tollhouse keepers Ben Pitts and his wife. The rates of toll are posted on the post to the left of the welcome sign. At this time only foot traffic, wagons, and animals passed through this toll station since the gasoline-powered vehicle had not yet come into production.

In this later photograph, taken about 1925, we see the tollhouse from the west with an automobile parked alongside. By this time, Dad Tillitt had taken over and was aided by his wife, Demaris, and their children Nancy and Morton, or "Mort," who cared for the store and cooked meals for visitors.

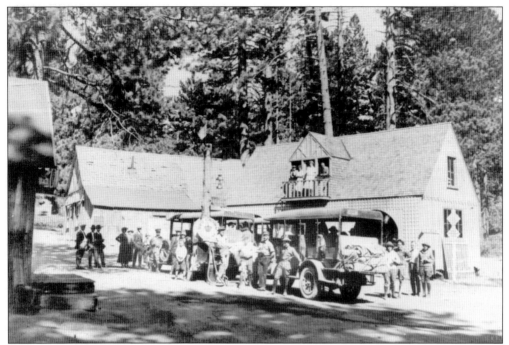

The Bear Valley Transportation Company began regular trips to the mountains in May 1913, bringing passengers and supplies to Green Valley and Big Bear Valley. Max and Perry Green also traveled this route with the Mountain Auto Line stages and, between the two companies, shuttled hundreds of tourists up and down the mountain.

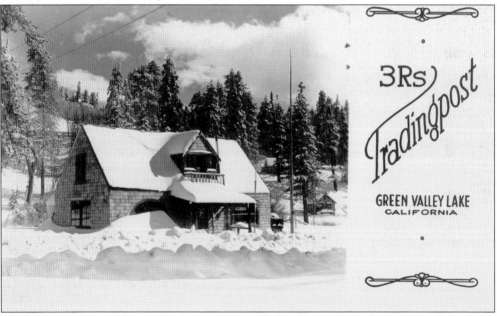

The Trading Post stood for many years in Green Valley as the center for dry goods. It also appears in the above photograph. Located near the entrance to the USFS campground and run like the toll station by the Tillitt family, it was for many years a store and a place of social activity for those who built cabins in the valley.

This most recent photograph of the Trading Post shows it in its final stage of existence. Almost destroyed by a falling tree, the "Big House," as it was called, was a store by day but on warm evenings and weekends, the lower floor was converted into a dance floor and, like a magnet, it drew every couple and single person to enjoy an evening of fun and good food.

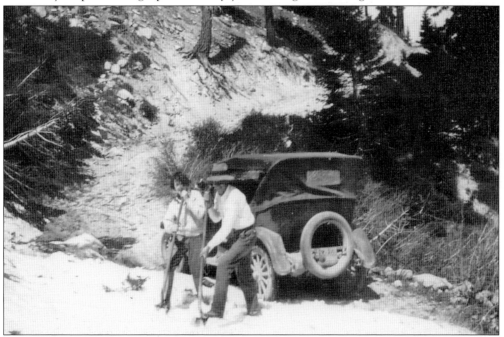

The Snow Slide Road, which ran from Green Valley to Big Bear Valley, was a place to find snow even in the hot summer days. Here, in 1927, the Powers family is loading up with snow that fell months before and will take it to their Deer Lick Store to keep drinks cool.

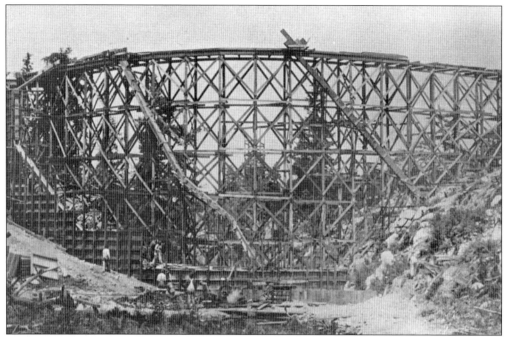

The De Witt-Blair Realty Company of Los Angeles purchased most of the Green Valley land and formed the Top o' the World Club, raising $80,000 to build a dam across Green Valley Creek. In 1925, the dam was under construction (as seen in this photograph) and would eventually create a lake of approximately 10 acres, with three-fourths of a mile of shoreline at 6,850 feet elevation, 106 feet higher than Big Bear Lake.

"Ever since I been drinking this water at Green Valley Lake I ant had a bid of asmy, ner no rheumatiz, and even my corns feel better. I'll betcha million$$$$$ that ef you city folks cud drink a glass of this stuff a day, there wouldnt be no need of a single horspidal in Los Angeles county."—Green Valley Mac, in a brochure from 1926 advertising Green Valley properties.

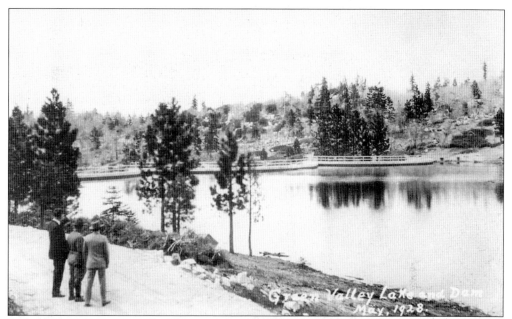

In this May 1928 photograph of the newly built dam and Green Valley Lake, it appears that some prospective investors are contemplating an investment. Note that there are no cabins around the lake, as few trees remained after Brookings cleared the area. No one is on the lake, and the road is still dirt. It would be a few years before the public would discover this secluded mountain jewel.

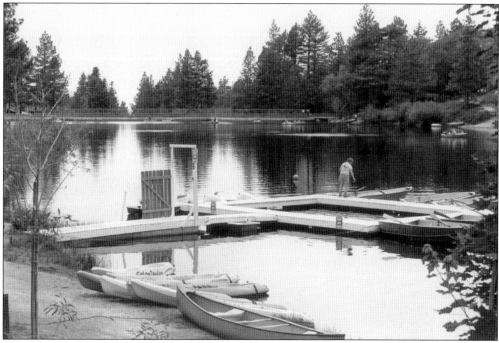

This contemporary photograph shows the lake from approximately the same position as the one above. The trees have grown back over time, the lake is busy with fishermen, and the boat-rental facility has most of its boats out. The lake is private and nonresidents are charged for fishing, swimming, or boating.

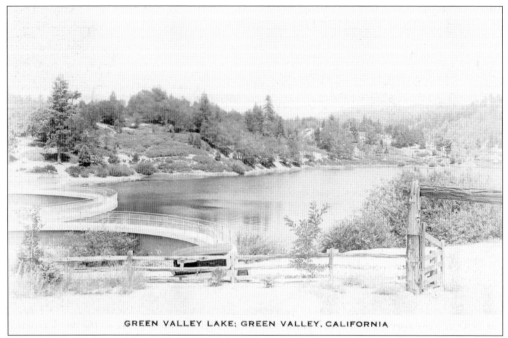

GREEN VALLEY LAKE; GREEN VALLEY, CALIFORNIA

This 1910s postcard, taken from the shore near the southern view of the dam, shows the undeveloped land with not a single structure on the north shore of the lake. The lake filled within one year of being finished, and the developers charged $6 for a trip to the valley from Los Angeles, with meals included.

Pictured here are the dam and lake today. "Cabins," some of which are larger than an average home, now occupy much of the private land. Einar Lilleberg, for whom the museum is named, came here in 1929, fell in love with the area and the Tillitts' daughter, purchased land, built a house, and remained a property owner until he died unmarried in 1985, having never attracted the attention of young Miss Tillitt.

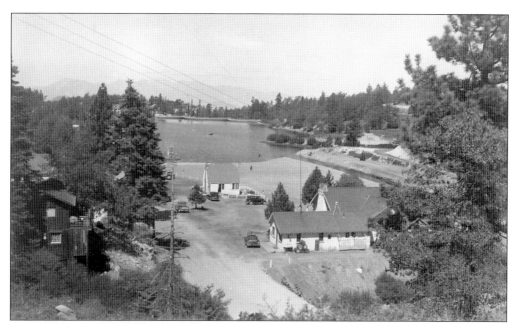

This 1930s real-photograph postcard, looking across the valley and the lake, shows the development that had taken place in the five or more years after the lake was built. Cabins and businesses were growing to meet the needs of tourists, who came mostly in the summer but also in the winter to ski on a forest-service slope just south of town.

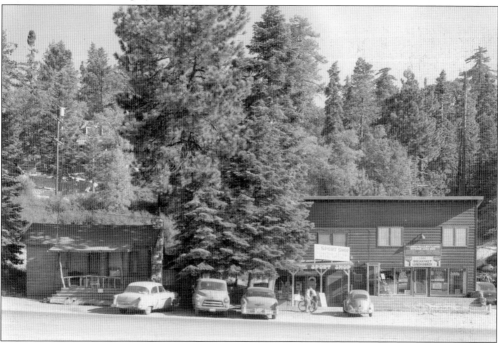

This photograph from the mid-1960s of downtown Green Valley shows the main street and quiet atmosphere not found in many communities, whether down the hill or on the hill. Pictured here is the Green Valley Lake store and inn, where breakfast and dinner were served. A traveler won't find any fast-food restaurants or shopping malls here, just a few "Mom and Pop" businesses.

The Top o' the World Club was exclusively for property owners and was organized to boost the sales of property by the De Witt-Blair Realty Company. The Union Station Depot in Los Angeles charged $10.30 for a round trip, which left L.A. every day at 8:00 a.m. Travelers went by train to San Bernardino and up the mountain by bus, arriving in the valley by noon.

In this recent photograph, the main street of Green Valley Lake in front of the Fox Lumber Company (open all year) can be seen. George Fox and Charles Clark, from the 1930s through the 1960s, were responsible for the water system in the valley. Lawrence Ferguson, Joe Fox, and Frank Dyer kept the ski lift operating, a fine example of cooperation of this small community.

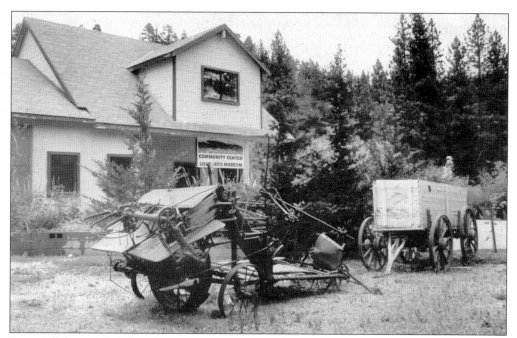

Einar Lilleberg willed that this museum be built and left money for its construction. It stands as a monument to his love of the valley and its people. Today it houses many photographs, items of Native American lore, relics from the Brookings Lumber and Box Company, a diorama, and meeting rooms. Unfortunately it is seldom used or visited.

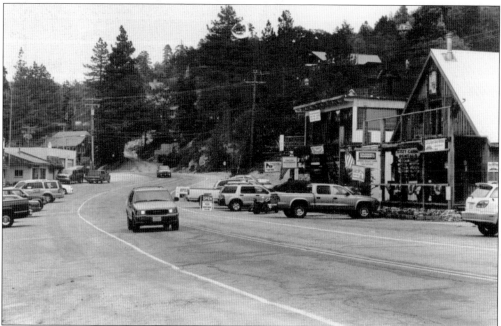

When looking toward the east, down the main street of Green Valley Lake, just about the whole business district is visible. The lake is to the left and the post office is at the far end, as are a market, a café, and real estate office. The water company and fire department are up the road that leads to the USFS campground.

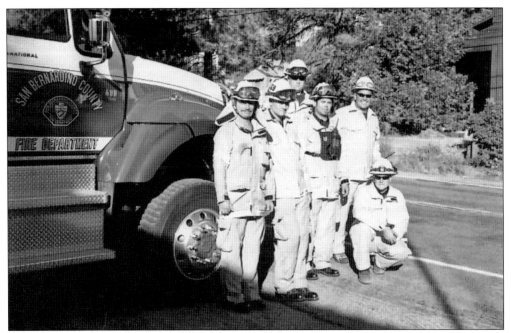

Green Valley Lake is no different than any other mountain community and maintains an on-call fire department manned mostly by locals. Pictured here are, from left to right, Paul Hartman, Daniel Casner, Jason Davis, Scot Turknette, Russell Warren, and Joe Garcia. The area has been fortunate in that it has escaped the recent destructive fires that have plagued other mountain communities.

While this family enjoys a cool swim in the lake in this contemporary photograph, few remember the spring of 1938, when the overflow clogged with debris. Luckily no one was in the valley as water began to run over the top of the dam. A hero appeared in the form of Jim Reid, one of the few permanent residents in the valley, who cleared the overflow and saved the dam and the lake!

The USFS maintains a campground at the east end of Green Valley, just beyond where the tollhouse once stood. It is not open all year, due to the heavy winters. Here campground host Mitch Swatez (right) of Laguna Woods, California, poses with campers Craig and Leslie, and their children Michael-Michele and Corey.

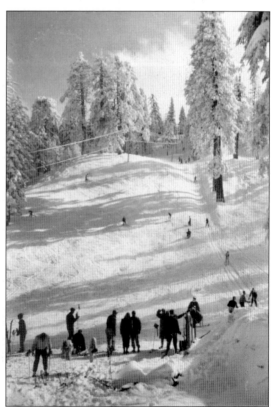

The ski slope on the south side of Green Valley is operated by the USFS and here, in its early days, a rope tow takes skiers to the top of the slope. It has become popular in recent years with snowboarders. Due to the altitude, good snow conditions can last into the early spring.

Old-time residents can remember the winter of 1968–1969, when one had to leave or enter his cabin through the second-story window. At times like this, when the roads are closed and there is no power, one might as well plan to stay awhile.

Many of Hollywood's best have visited Snow Valley for a day of skiing, and here, in 1976, Buddy Hackett kindly poses with a mountain local, Christina Miller, from the local high school. The high school may not have a swim team but it conducts classes on the nearby slopes in skiing and snowboarding, one advantage to living in a mountain community.

IN MEMORIAM. During the preparation of this book, three mountain people have passed on. First was John Elvrum, born in Trondheim, Norway, who changed the name of a small and insignificant ski slope called Fish Camp to Snow Valley and created a business that provided jobs for mountain youth and locals for more than 30 years. Not only has it provided income for locals, it has offered over the years a multitude of fun-filled recreational activities (including downhill bicycling) for everyone who cared to make the trip to the mountains. Elvrum had a long and distinguished career, not only as a businessman, but as a competitive skier (he held the American ski-jumping record of 240 feet) and as a member of the U.S. Army's 10th Mountain Division ski troopers during World War II. He had the honor of being entered into the U.S. National Ski Hall of Fame. Elvrum was 97 when he died. Second, was Charles Hoffman, principal of the Running Springs Elementary School for 30 years, who died at age 82. The school now bears his name (see page 91). Third, Robbie Robinson, the premier historian of Green Valley Lake died, leaving a legacy that will not be forgotten for generations to come among the residents of Green Valley. He was 89. All three are missed, and their memory will be cherished among all who knew them.

Across America, People are Discovering Something Wonderful. *Their Heritage.*

Arcadia Publishing is the leading local history publisher in the United States. With more than 3,000 titles in print and hundreds of new titles released every year, Arcadia has extensive specialized experience chronicling the history of communities and celebrating America's hidden stories, bringing to life the people, places, and events from the past. To discover the history of other communities across the nation, please visit:

www.arcadiapublishing.com

Customized search tools allow you to find regional history books about the town where you grew up, the cities where your friends and family live, the town where your parents met, or even that retirement spot you've been dreaming about.